D0860374

REAL PRESENCE

REAL PRESENCE

In Search of the Earliest Icons

Sister Wendy Beckett

ORBIS BOOKS

Maryknoll, New York 10545

Founded in 1970, Orbis Books endeavors to publish works that enlighten the mind, nourish the spirit, and challenge the conscience. The publishing arm of the Maryknoll Fathers and Brothers, Orbis seeks to explore the global dimensions of the Christian faith and mission, to invite dialogue with diverse cultures and religious traditions, and to serve the cause of reconciliation and peace. The books published reflect the views of their authors and do not represent the official position of the Maryknoll Society. To learn more about Maryknoll and Orbis Books, please visit our website at www.maryknollsociety.org.

First published in Great Britain in 2010 by
The Continuum International Publishing Group Ltd.
The Tower Building
11 York Road
London SE1 7NX

First published in the United States in 2010 by
Orbis Books
P.O. Box 302
Maryknoll, New York 10545-0302

Copyright © 2010 by Wendy Beckett

All rights reserved. No part of this publication may be reproduced or transmitted in any form or by any means, electronic or mechanical, including photocopying, recording or any information storage or retrieval system, without prior permission in writing from the publishers.

Queries regarding rights and permissions should be addressed to the publishers.

Printed and bound in Great Britain by the MPG Books Group

Library of Congress Cataloging-in-Publication Data
Beckett, Wendy.
 Real presence : in search of the earliest icons / Wendy Beckett.
 p. cm.
 Originally published: London : Continuum International Pub. Group, 2010.
 Includes bibliographical references.
 ISBN 978-1-57075-898-0 (cloth)
 1. Icons, Byzantine. 2. Christian art and symbolism--Medieval, 500-1500. I. Title. II. Title: In search of the earliest icons.
 N8189.B9B43 2010
 704.9'482--dc22
 2010012514

*This book is dedicated
to our own monastic iconographer
Sister Veronica.
I would also like to express my deep gratitude to
Sister Liza, Sister Lesley, and Sister Gillian
and
To Fr Stephen Blair, who has typed every word.*

Some time ago, to my astonishment, I discovered the eight icons of the Virgin that have survived from the sixth century. They are the only survivors. In the eighth and ninth centuries the Byzantine emperors waged relentless war on icons, and these eight Virgins only escaped because they were beyond the emperor's grasp. What so astonished me was their individuality, their unlikeness to what we know as 'icons'. 726 is a cut-off date. When icons came back into favour in 843, they were different, and much more regulated. The early icons have all the emotion and drama of early Christianity. They were a revelation to me. I went on pilgrimage to see them all, and the book I wrote about it I called *Encounters with God* (Continuum, 2009), which is the nearest that I can come to describing the impact that their deep spiritual beauty makes.

However, in searching out the eight Virgins, I discovered that they were not the only early icons. These too, to a greater or lesser degree, have a presence that I can only call holy. One of my projected titles for this book was 'A Real Presence'. I have not used it, mainly because it could be confused with 'The Real Presence', which of course refers to Jesus in the Eucharist. Yet

there is a true parallel. Jesus is present, body and soul, under the appearance of bread and wine, and He is also present under the appearance of an icon. He is not represented in an icon, any more than He is represented in the Eucharist: He is truly there, though not in the same way. Contemplating the icon, with faith and love, draws us out of our material world and into that divine world to which we will only have full access after death. On this earth, we live in His kingdom, but in hope and faith, not in experience. These early icons with their pure desire to praise God, draw us very strongly into this unseen reality.

I had been so preoccupied with the eight Virgins that until I saw them, I had not fully taken on board these other icons, as early as the Virgins and often as serenely beautiful. The great treasure house of pre-iconoclastic icons is the Monastery of St Catherine at Mt Sinai. In fact, this is the great treasury of icons, full stop: they have over three thousand. But post iconoclastic icons, especially from the thirteenth century on, are to be found all around the world. They are an integral part of the liturgy of the Orthodox Church. Yet nowhere else has there been a place

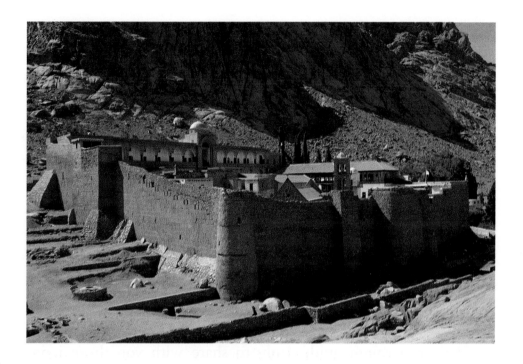

where so many pre-iconoclastic icons have been revered and cared for. The Emperor Leo III, and his immediate successors, did a thorough job of destruction. Hardly anything remains except at Mt Sinai and a scattering in Rome. There may be more to be discovered, since not all that long ago an extraordinary icon surfaced quite unexpectedly in an auction house in Avignon, so who knows what else is still to be found?

Kurt Weitzmann, the Princeton University professor who was the first to attempt a catalogue of what he found at the Monastery, concluded that there were about forty. But when you look at his catalogue, you realize that quite a few of these are almost indecipherable.

Great scholar that he was, Professor Weizmann decided that every icon, however battered and worn, had an 'archeological' value. There is something moving about a sixth century wooden panel, on which there was once a sacred image, and that it is still reverently preserved by the monastery, in its ghost form. I have decided, as a rough guide, only to share with you those icons to which I myself have responded. There is also a problem at Mt Sinai as to whether we should adhere rigidly to the cut-off date of 726. All these icons only survive because the monastery was a very great distance from Byzantium. They were in contact with Alexandria in Egypt and with Jerusalem in Palestine, and the violence of iconoclasm passed them by. Obviously, since most of their icons came as gifts, probably as votive offerings in thanksgiving to God for answered prayer, or as a perpetual

prayer in themselves, iconoclasm did affect them. There would have been fewer gifts, nothing from Byzantium, which was still Constantinople then and in our day has mutated to Istanbul. So I have been unconcerned about venturing into the late eighth or even the early ninth centuries.

However, St Catherine's Monastery is the obvious source for early icons: there they are, dozens of them. We tend to forget that it was by no means the only early monastery. Throughout Egypt there were flourishing Coptic monasteries, sometimes with as many as five hundred monks, who also expressed their faith in icons. These icons are far more scattered. Some are still in Egypt, some in the Louvre or in Berlin or in New York or in other cities in Europe and America. They are not easy to track down. Whenever I thought I had found all of them, I would come across an example, touching and beautiful, that I had never seen before. Moreover, the definition of an icon is that it is a sacred painting on wood, and is portable. This portability is important. When finally, in the fourth century, Christians were allowed to build churches and the Emperor Constantine became

their influential patron, these churches were glorious with mosaics and wall paintings. This was part of public worship; they were for everybody. But at first, beginning rather hesitantly in the fifth century and swelling to a crescendo in the sixth and seventh, icons were personal.

In the gospels, Jesus speaks of going into your room and shutting the door and praying alone. These early icons fulfilled a need of personal piety, some of them have ridges to show where a lid had fitted in order to make it easier to carry around. We know very little about the silent individual prayer of our ancestors, and the icons are a precious light upon this. Afterwards, of course, they became common in churches, as they still are, but they have never lost the intimacy 'portable' implies.

And herewith is my problem. There are quite a few small Coptic icons, fully portable, but some of the most striking examples are in fact non-portable: they were painted on the walls of the monks' cells, a prime example being the monastery of Bawit which was on the left bank of the Nile about midway between modern Cairo and Luxor. If a monk chooses an image to be painted in his own

cell, a cell in which he will spend his entire life, surely this is genuinely an icon?

I noticed with interest, that in Weiztmann's great book on the early icons at the Monastery of St Catherine, he includes two wall paintings, even if in his individual description of them he refers to them as 'paintings' and not as icons. (They were painted on two marble pillars, one showing Abraham's willingness to sacrifice his son Isaac and the other showing Jephthah's sacrifice of his daughter, and since both are indistinct and – to me – uninspiring, neither is in this book). Nevertheless he has listed them in his study of the icons, and I think a far stronger case could be made for the monks' cells in the Coptic monasteries. Sometimes these wall icons are so fresh and lovely that we feel at once the joy of that long ago monk as he knelt, probably for hours, to contemplate them.

There may well be more early icons, and there may be museums and collectors writing plaintively to ask why their beloved master-pieces are missing, but I feel that there is enough here to give everyone a taste of the spiritual happiness that is there for the asking, for the seeking, for attention.

Mt Sinai is one of the great holy places of our earth. It was here, at the foot of that forbidding mountain range, that Moses came across a bush that was burning but never consumed. From the flames came a divine command: 'Remove the sandals from your feet for the place where you stand is holy ground.' It has been holy ground ever since.

Moses dared ask the name of God, a foolish request since to name is to comprehend and God is of another quality of being, fitting into no human categories. He answered Moses with a divine irony. He said His name was JHWH into which we insert vowels to make it pronounceable: Yahweh. Yet the word seems untranslatable. Hebrew scholars tell us it means 'I Am' or 'I Will Be' and the new English translation of the Bible says 'I Am Who I Am'. This is an enigmatic way of saying that God is pure Being, incomprehensible to humanity.

It was only centuries later, when Jesus was born, that Moses' question could be answered. We now know that God is Father and God is Love. If this were not enough to make Mt Sinai a place of pilgrimage, one of the great forbidding peaks of that range that

circles the valley, it was the place to which God summoned Moses to learn how human beings should behave.

We call what God revealed the Ten Commandments, and they are remarkable for their simplicity. (Think of the complicated rules and practices of some ancient religions, dominated by fear of not getting it right, unaware of the need to trust.) What God stressed was the need for respect, for reverence. He told Moses that first we should honour God Himself, the true God, not placating ourselves with small, man-made objects of worship, 'false gods'.

He stressed the need to take God seriously: 'Thou shalt not take the name of the Lord Thy God in vain.' He explained that we need one day in the week in which we are to rest from work and become aware of what God is. But it is not only God that we are to honour; seven of the commandments are concerned with ourselves and our world. We are to honour other people, first of all our parents, and then everybody else. We are to respect their property, their marriages, their reputations, their lives. Everybody has a right to be treated with dignity. We are to honour ourselves too, not getting embroiled in greed and lust, 'coveting' this or that,

unable to be happy with ourselves. Like God's revelation at the bush, that He is Holy Mystery, this revelation on the mountain set out the way in which humankind was to grow, to become responsible and alert to the wonder that surrounds us.

No wonder then that from early times Mt Sinai was not only a place of pilgrimage, but a place for men of prayer to live, contemplating such a revelation.

We have the good fortune to have part of a travel diary written in about 380 by a Spanish nun called Egeria. She would certainly have called it a pilgrimage diary. She must have been a very tough lady, of inexhaustible energy, and she took her sacred wanderings very seriously. She describes the holy excitement of coming to Mt Sinai, and how the monks welcomed her and showed her, of course, the sacred bush (the bush lasted for centuries, and some hold that it has been transplanted to part of the Monastery property). These were scattered monks, and when next we hear of them in the sixth century, they have applied to the Byzantine Emperor Justinian for protection.

Justinian was a supreme builder of churches and monasteries: it

is he who gave the world what many considered the most beautiful of all churches, the Basilica of Santa Sophia in Constantinople. But as well as a great builder and patron, he was also an astute statesman, well aware that the furthest reaches of the great Byzantine Empire were pitiably undefended. He agreed to build the monks a fortress monastery, one that could resist hostile attacks, and he built it so superbly that it stands majestically to this day. He sent them too what may well have been the most gifted mosaic artist of the century, to create within their small church a great mosaic.

The monastery was dedicated to the Transfiguration, and that is the theme of the wonderful soaring mosaic that would have greeted all who entered the monastery church. It is blocked now from immediate sight by hanging lamps and the iconostasis (the row of icons that screens the sanctuary in Orthodox churches). We may have to move into the sanctuary and look upwards, but it is forever there, a glowing exhalation of the majesty of Christ. (It has just been restored, and the newly revealed brightness of the mosaic squares is a visual expression

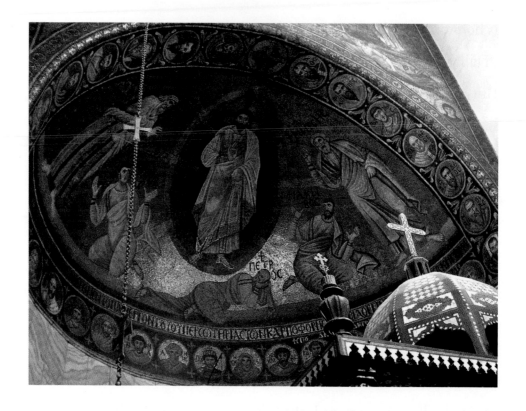

of the luminous light which dazzled the three apostles who were witnesses).

Later, the dedication was changed to St Catherine which is the name the monastery now bears. This is the oldest continuously inhabited monastery in the Christian world. It has functioned as a place of prayer and praise since the time of Justinian. If one

comments admiringly to one of the monks, he may reply modestly that there is said to have been a period, around about 1565, when the monastery was empty. If so, this is a technicality, since essentially this house of God has been home over the centuries to dedicated and earnest men, from all walks of life, committed to a life of silence and austerity in which they can receive the fullness of God's grace and hold it there in the world as a comfort and a joy to others.

There is a lovely appropriateness in the fact that it is this monastery that has become the resting-place of some of the oldest Biblical texts in existence and of the extraordinary collection of pre-iconoclastic icons.

To venerate icons, the images of our Lord and His saints, seems so natural to Christianity that we may be puzzled as to why there is no evidence of them until the late fourth and fifth centuries, and even that is only literary.

The earliest icons that we actually have date from the sixth century. Yet this should not surprise us. For the first two centuries

of our era, there was no Christian Art at all. This was partly because most Christians were poor, partly because their public unpopularity would have dissuaded them becoming in anyway noticeable, but mostly, I think, because of their cultural isolation.

This is something that we find almost impossible to imagine. Those early centuries were a time marked by visual magnificence. The streets were resplendent with temples and baths and theatres, all adorned with large and imposing sculpture. What we find challenging to comprehend is the all-pervading atmosphere of pagan belief.

For centuries the Roman Empire had worshipped many gods. At every turn the instinctive, long-held belief in these gods dominated society. All social life was based on an unconscious awareness of this all-pervading pagan culture: it was instinctive. Christians had to watch that the meat on their table had not come from the Temple. If they went to a tavern, they had to risk causing comment because they abstained from the custom of pouring a libation to the gods. The language was soaked with pagan expressions and references. As well as the statues

of the gods in public, every home had its lares and penates, the household gods that honoured the ancestors. Above all, the Christian could not attend the great ceremonies of public worship which prayed to and honoured the Emperor. The danger, the isolating danger, was that everybody took it for granted that it was a loyal Roman's duty to invoke the gods on behalf of their country.

Around about the year 180, a Roman citizen of whom we know little more than his name, Celsus, and his views, wrote a treatise expressing his shocked bewilderment at what he clearly saw as immoral behavior. Christians wanted to live in the Roman Empire and enjoy the tranquillity of its order, yet they actively worked to undermine it by refusing to take part in public sacrifice. He said that they lived in a state, these ungrateful Christians, of 'perpetual apostasy'. We can understand why the Emperor and his officials saw this refusal as deliberate immorality.

Although investigations – we have the letters of Pliny the Younger to the Emperor Trajan – seem to show that the Christians did nothing but meet once a week and engage in 'an ordinary

harmless kind of meal', they were still a public menace because they were angering the gods.

Our own times have coined the expression 'internal exile' to express the loneliness of those who live in an alien culture such as Christians and Jews in communist Russia. The Christians endured this painful alienation from their neighbours and friends and family for over three hundred years.

Our modern Jews and Christians trying to survive under an atheist dictatorship have nevertheless much to support them. They know their religion, and they understood that their condition is an aberration. But our early Christian ancestors had very little to support them. We think of the Faith as being preached and spreading and offering spiritual solidarity to all who accepted it.

But what precisely was this Faith? In many, many cases it must have been little more than a certainty of the saving power of Jesus and a desire to receive the spiritual freedom that His missionaries described.

There is an illuminating anecdote in the Acts of the Apostles,

describing exactly the progress and the process of early mission activity. St Paul comes to Ephesus, and meets there a group of Christians who he himself had not converted. In dialogue with them, he asks if they have 'received the Holy Spirit?' Obviously these new believers are flabbergasted: 'we have not so much as heard that there is a Holy Spirit!' There may well have been small clusters of Christians all over the Empire, holding fast to a belief in Jesus, yet not quite sure exactly who or what He was.

Remember, there was no New Testament as yet. The great Athanasius, Bishop of Alexandria, used to send out every year what he called a Festal Letter. It was a pastoral letter telling his flock the date of Easter and any other festal dates that they needed to know. He died in 373. One year, clearly, he had become aware that people were confused as to what was Christian scripture and what was not, and his Festal Letter provided them with a list. It was an interesting list. The *Shepherd of Hermes*, that beautiful book, was out; the *Revelation of St John*, that difficult book, also known as the Apocalypse, was in. The Christian world seems to have decided that what was good enough for Athanasius was good

enough for them and his twenty-seven books have remained the canon of Scripture ever since.

Yet the interpretation of these books could differ quite dramatically. The Arians against whom St Athanasius battled so valiantly, held that Jesus was truly God but not truly man. Then there were the Adoptionists who believed that Jesus only became God at his baptism, when God adopted Him. There were the Donatists and the followers of Origen, the former demanding almost impossible levels of purity and the latter very relaxed and 'modern' in their thinking.

The Council of Nicea, in 383, which the Emperor summoned and in fact controlled, settled many difficulties with what we now call the Nicene Creed. There is a sense in which none of these uncertainties affected the strength of the individual Christian's faith in his Lord, but it must have undermined that sense of solidarity with other Christians that today we take for granted.

The Emperor Constantine's conversion at the beginning of the fourth century brought Christianity out of its internal exile, and

one could almost say that the Edict that he issued in Milan in 313 marks the beginning of Christian art.

Roman and Greek art displayed itself in sculpture, in mosaic and in wall painting. Very little of this remains. Most likely to survive were the mosaics, because they were floor coverings as opposed to the paintings which were on the comparatively fragile support of walls. Walls all too easily fall down or are burnt or modified by a new owner. Even today, archaeologists are revealing extraordinary mosaic floors and the occasional broken sculpture, but there is hardly any wall painting to be seen except in the accidentally preserved city of Pompeii.

By another accident, though less traumatic, there actually survive some early Christian wall paintings from the year 240. The little Syrian town Dura-europos, on the banks of the Euphrates, sealed up its outer walls in an attempt to fortify them and in those outer walls were two small houses, that each contained a place of worship. One was a synagogue and one a very small church. To the amazement of archaeologists, both places of worship had painted scenes from the Scriptures on their walls. The synagogue

painter was a good deal more skilful than the jobbing craftsman who was all the Christians could afford, but neither was capable of producing genuine art.

That was to come later, after the Edict of Milan, when Constantine first permitted Christianity and then eventually accepted it as the State Religion, and hence deserving the spaciousness of Basilicas in which to worship. Up to then, more or less, there were only floor mosaics. Those great wall spaces, and the Emperor's ready purse, inspired the creation of wall mosaics, which have been the glory of the church ever since. So little can be preserved through the centuries that it is not surprising that we only have visual evidence of this public or liturgical art. The icons, which arose from private devotion, would of necessity have taken time to move into the public sphere, with the consequent possibility of preservation.

Scholars agree on the great significance for the art world of the discovery of the early icons of Mt Sinai. Thomas F. Mathews calls it a 'major event for the history of art.' This is obviously true,

in that centuries which seemed to be empty as far as painting is concerned, were now populated: art historians had much more on which to work.

Yet the great significance seems to me to be spiritual. We had been cut off from this visual expression of early Christian faith, and the wonder of the icons at Mt Sinai lies far more in what they reveal to us spiritually than their aesthetic importance for historians.

Icons are in a peculiar position. Incontrovertibly, they form part of the body of art history. Historians can look at them and make stylistic deductions and appreciate beauty of technique. Yet this seems to me a sort of by-product, not their day job, as it were. That day job, their real meaning, is the same today as it was in the sixth century: they draw us from the limitations of our own pressured world into the Kingdom of God.

I first went to the Monastery of St. Catherine at Mt Sinai as the last station of my pilgrimage to see the eight surviving icons of the Virgin. I had been to Kiev in the winter snows (one of the Sinai Virgins was taken there in the nineteenth century), to

Rome in the warmth of an Italian autumn, and I had seen the late discovery, the London Virgin, in all seasons of the year. The journey to this remote Egyptian desert was by far the most difficult of my travels, and my anticipation was correspondingly intense.

Let me say at once that the Mt Sinai Virgin is exceeding beautiful and in no way a disappointment, yet when I went into the small room in which the monks have sequestered their greatest icons, I could hardly see the Virgin because of the icon beside her. This is the icon of Christ Pantocrator, surely the most wonderful icon in the Monastery, perhaps the most wonderful icon anywhere. It had bothered me that the great surviving icons had all been those of the Virgin. There were early images of Christ in Rome but they were all mosaic. Perhaps the earliest image of all is hidden under multiple re-paintings in the Sancta Sanctorum, the innermost recesses of the Vatican Museum. It can no longer be seen, and probably has been worn away to invisibility under the weight of re-painting and silver embellishment, but there is a legend that this was at one time an image 'not made by human hands. ' Jesus is said to have imprinted it on a towel and sent it to Abgar King

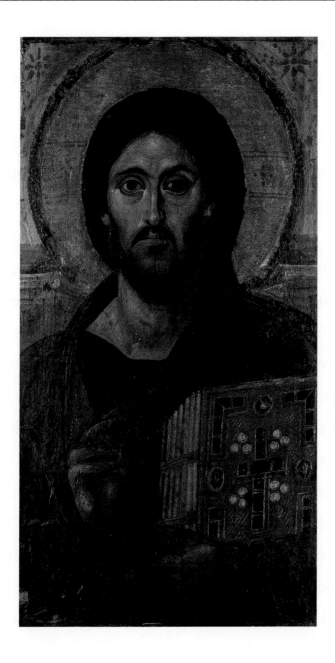

of Edessa in Syria. It was taken to Constantinople and treasured there until it was lost during the Crusades. This was called the Mandylion.

There was a second image 'not made by human hands', the veil of Veronica. That too, if it ever existed, has disappeared. Yet at some stage there must have been an image of Jesus that was accepted as 'real'. The Mt Sinai icon reflects other images, for example on early Byzantine coins. It is also said to reflect the great icon that stood above the gate of Chalce in Constantinople, which Leo III destroyed at the beginning of iconoclasm.

Those who are unwilling to accept the scientific conclusions about the Shroud of Turin see the same strong noble face there. But this is the earliest icon of Jesus. The books entitle it 'Pantocrator', Christ All Powerful, but that title was only given it in the ninth century. Looking at it untitled, we see primarily a Christ who blesses, and in His other hand holds for us the bejewelled treasury of the Scriptures. This is a work of the utmost delicacy and subtlety. Behind Jesus is a classical façade with fields beyond and a sky above. He is in our world, He is human.

The great sticking point in the early centuries, which in the end would lead to iconoclasm, was the possibility of showing the human Jesus. He was also God: how could there be a visual expression of Divinity? This sixth century painter, almost certainly a master from Constantinople, shows us a Lord of such majesty, and yet of such humanity, that we are able to accept the mystery of His being. We can never fathom Jesus, but this image assures us that He can fathom us.

This noble Jesus, dark-haired, with a light beard and moustache, was to become the accepted image of the Lord. We have seen countless reproductions of this beautiful face. Almost certainly the painter sent to Mt. Sinai a reproduction of an image already revered in Constantinople. For the icon painter, reproduction is the norm, not a lesser form of creation.

Whereas Titian, say, or Rubens or Michaelangelo paint what they imagined Jesus to look like, the icon painter reproduced what he felt was the true image, what Jesus did in fact look like. In this context, therefore, it is fascinating to realize that this Sinai

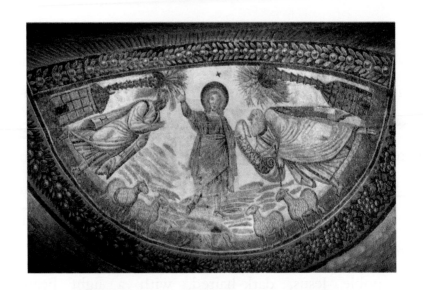

image, which has been visually all conquering, is not the only icon to represent Jesus.

Leaving aside icons, which after all must date from the fifth or sixth centuries, we have mosaics which are in fact a good deal earlier. If we are dependent on the 'truth of the image', what are we to make of the mosaics in the apse of Santa Constanza? This is where Constantine's daughter was buried in about 350, and this Jesus is young and golden-haired, with

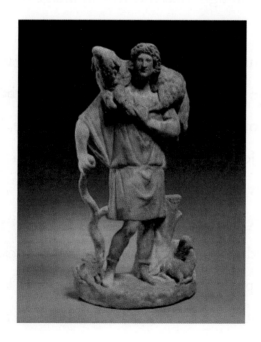

very little facial hair. Nor is the image unique. The great sequence of mosaics in Milan shows a young, fair-headed Lord. The earliest of all images of Christ is that of the Good Shepherd. We see Him young, fair and beautiful in the catacombs carrying a sheep.

Sometime around 280–90, an artist in Asia Minor produced perhaps the most beautiful of the Good Shepherd images. Christians were still persecuted at this time, but hostile viewers might well have thought that this was an image of Apollo, or some pastoral divinity. It was the protective Jesus, the Saviour, that so filled the imagination of the first Christian generations.

It took some time for them to settle into the security that Constantine brought them, and to visualize the Lord who was without doubt Jesus, Son of Mary, unique, never to be confused with a pagan divinity.

Yet the difference between these two depictions of Jesus make me query whether the artists, whether in a mosaic or a panel painting, were primarily concerned with what He looked like. This is our concern: we want to know. Just as the Gospels are

baffling to the modern mind with their total indifference to Jesus' appearance or temperament, so perhaps we must accept that the images have some deeper purpose. The gospels are trying to make us aware of what Jesus was, what He meant. Perhaps the icons and the mosaics are the same?

The mosaics show us a Jesus who expresses a freedom from earthly burdens, from all the self-centered weariness that we know all too well. The Apostles among whom Jesus sits, or to whom He gives instruction, are men like ourselves, burdened, ageing, struggling. The 'young Jesus', whatever His actual age, soars radiantly above all earthly perplexities. The Sinai icon is a much more human Jesus, but one who is able to bear all our burdens. His gaze is compassionate, perhaps slightly sorrowful. He knows we are sinners, and He knows what sin is, though not from personal experience. He is there to bless us, and to teach us, and to make us certain that in Him we can defeat the world in which we are so painfully involved.

However, whatever the lip service in subsequent times paid to the fidelity of the icon to the real appearance of Jesus, it is

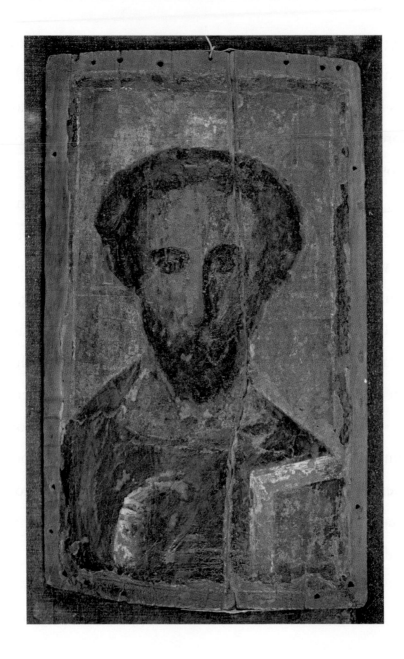

nevertheless what He signifies that matters. This is reinforced by the other Pantocrator at Mt Sinai. The comparison is almost alarming. Whereas the great Constantinople icon has a classical majesty, this second icon, also sixth century, has an almost pitiable appearance. It has been called Semitic as opposed to Classical, classical stressing the noble power of Jesus, semitic stressing His human weakness. This is the Jesus who could and would be crucified. This is Isaiah's suffering servant. It is exactly the same image in that Jesus raises a blessing hand, and in the other hand holds a book of the Gospels, though this book is not richly jewelled. For some time this image was repeated and loved. Both icons, the strong classical Jesus and the suffering semitic Jesus, appear on the imperial coinage. One of the great icons at Mt Sinai, that of St Peter, has a medallion inset, and so does the icon of Sergius and Bacchus, now in Kiev (see pages 90 and 94). We will see those medallions again when we look at the two icons, but in both cases the image is more akin to that of the suffering servant, Jesus who bears our weaknesses and will be physically crushed by them. With both these images

loved and revered simultaneously, it is clear that neither could have the sole prerogative of showing 'what Jesus looked like'. Both are showing what Jesus is, and both accept that no human power can give visual expression to the Divine immensity of that meaning.

Astonishingly, the third pre-iconoclastic icon of Christ at Mt Sinai is completely different. This is Christ enthroned, appearing in the likeness of what the Old Testament calls the 'Ancient of Days'. This strange and wonderful figure is described by the Prophet Daniel, and the few icons that draw upon this image tend to show Jesus as an eternal youth. Here He is shown as white bearded and white haired, and yet presenting us with exactly the same gestures as in the two earlier icons. His right hand blesses, His left hand holds the scriptures. It is a very complex icon in that it conflates the Ancient of Days from the Prophet Daniel with references to the Prophet Isaiah and the Prophet Ezekiel. Isaiah says, 'heaven is my throne and the earth is my footstool', and Jesus is seated on a rainbow, with His feet upon a sphere, only partially visible.

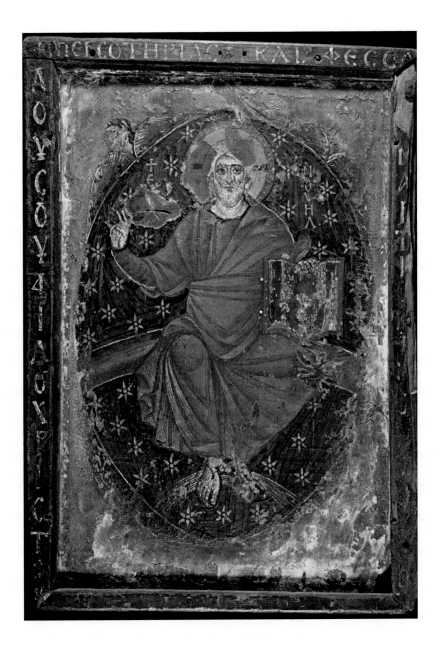

33

Around the mandorla in which He is contained were once the 'four living creatures' whom Ezekiel describes 'their wings were ... full of eyes'. We can still see the one in the upper left which was in the 'appearance of a man', and very faintly we can see in the upper right that there was an eagle, now barely visible. There are images that would have been at the lower right and left, the lion and the ox. It was these 'four living creatures' that the Church saw as representing the four Evangelists.

St Matthew was represented by the man or angel, St John by the eagle, St Mark by the lion and St Luke by the ox. Just as the semitic icon emphasizes the human vulnerability of Jesus, this prophetic Jesus, who bestrides time, soars in the heavens, shines forth among the stars, emphasizes His eternity. It is an immensely powerful vision, but we do not feel that closeness that is so marked in the great Constantinople Christ and that moves us in the Palestinian icon.

I am still surprised that there are not more images of the Lord from these early times. I cannot help but wonder if there lingered a sense that He was an image too sacred for human contemplation.

Later ages would become far less sensitive about this issue, and the Lord would be portrayed and revered throughout the public church and in all private devotions. Yet there is something touching in the shy reverence with which the sixth and seventh century Byzantine believers approached the sacred theme. Perhaps we are too ready to think we can 'look at Jesus'.

In the Coptic Church, on the other hand, the most common of all icons is that of Christ in Majesty. Remember these are icons painted on the walls of a monastic cell but painted there for worship and encouragement, and in this sense I feel they are fully iconic. As one might expect, the Egyptian Christ has not the classic stateliness that was to become the norm in the Byzantine Empire. He is stately, but the countenance is long and often thin, much more semitic in its poignancy.

There is a wonderful Christ in Majesty at the Monastery of St Jeremiah at Saqqara. Jesus is sitting on a throne which is richly adorned with jewels. He is supported by a decorated cushion, and as usual He blesses with one hand and holds the Gospels in the other, a magnificent Gospel book, as elaborate

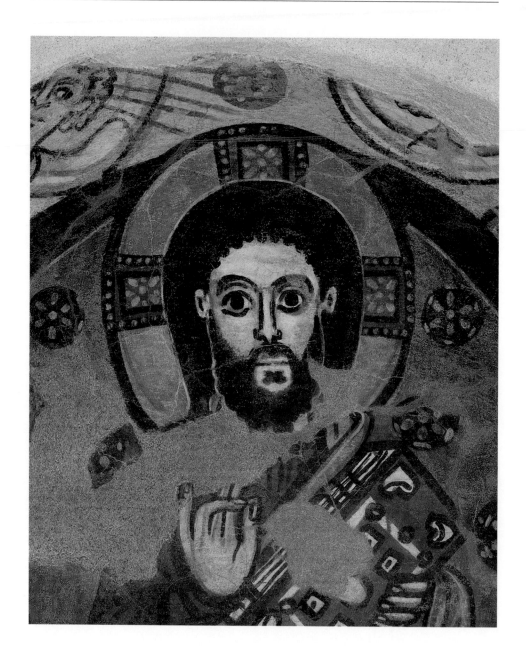

as His throne. He is in a mandorla, supported by the 'four living creatures' the ox, the eagle, the lion and the man, but the effect is very different from the Ancient of Days at Mt Sinai.

This Jesus fixes us with a compelling look, His large dark eyes very aware of our presence. His face is white, His beard and hair slightly ragged. He is more the man of sorrows than the man of power. In the same monastery, in another cell, is a Christ with angels. The niche is in the eastern wall of the cell, since the Coptic ritual emphasized that liturgy was to be orientated to the East. Again Jesus blesses and holds the book, but He is not seated, and He is not in a mandorla.

On either side angels hold out their hands in love and worship. The gentle dreaming expression of the Lord's face seems to suggest that He is lost in prayer to His Father. He does not look at the monk who would have been kneeling before Him but away into the distance. This is not a sad face – the artist portrays it as broader and even more robust – but it is clearly the face of one who knows what it is to suffer. His peace makes it equally clear

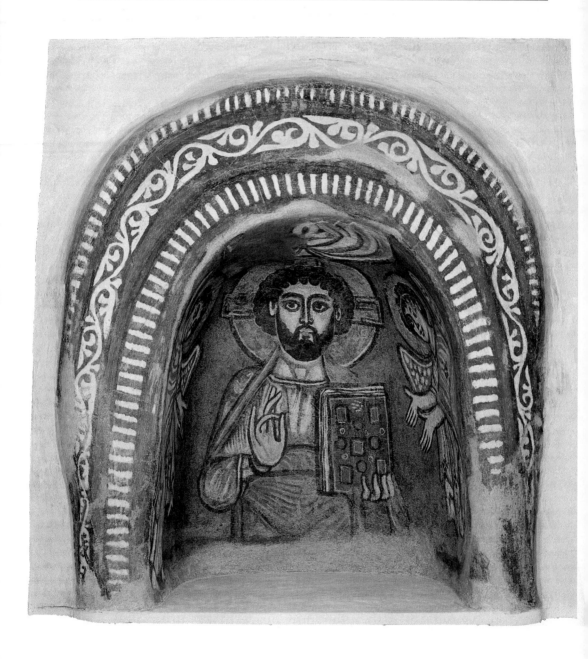

that He knows the redemptive value of suffering and understands what it is to be human.

Perhaps the most touching of all these Coptic images is the one in the monastery of St Apollo in Bawit. This is just the head of Christ, again in a niche, and it has a dramatic intensity that seems to me particularly Coptic. He has a long, almost elongated face, very pale, and His eyes are a very light brown. His hair cascades in waves onto his shoulders, deep black and untidy. He has a neat,

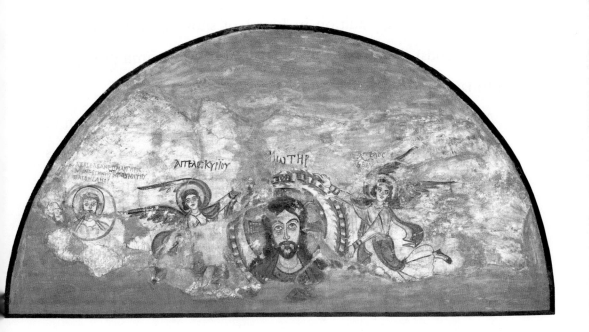

black moustache and beard which makes the redness of His mouth very noticeable. It is almost a sketchy Jesus, but it has what one might call a rapturous freedom about it, a sense of a glimpse of the reality of the Lord and a hasty desire to recapture something of that blessedness. Many of the Coptic images have an intimacy that clutches at the heart-strings.

The most famous is not that of Christ alone, but of Christ by the side of the Abbot of Bawit, Father Menas. Byzantine art tends to show Jesus alone or in the course of some incident in His life. There was a long tradition in Egypt of showing a man and his god (or gods) side by side. It was a way of proclaiming the god's patronage, and your own loyalty.

At least one strict Byzantine scholar has demurred at the icon of Christ and the Abbott Menas, feeling that it does not do justice to the importance of Christ. It seems to me, however, that the image is a touching and beautiful one. Menas is not the Saint Menas who was an early Egyptian warrior, widely renowned, his tomb a place of frequent pilgrimage, but a monk who had taken the name of Menas (or perhaps was given it at birth). It would seem that it

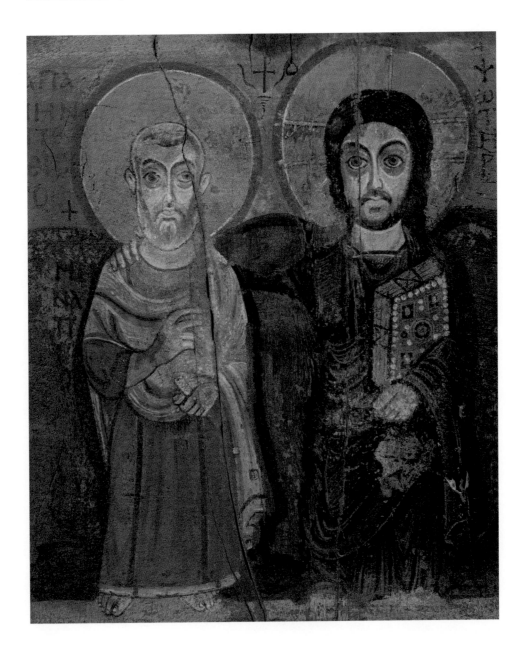

is his closeness to Jesus that gives him that resplendent halo. Is that not the definition of holiness, to be close to Jesus?

His face, gazing rigidly ahead, has the shy wonder that we must all feel at the certainty that we are being held by Christ He does not look at Jesus. In fact there is no visible proof that he is conscious of that protecting arm. We can only infer his confidence from that wondering expression, and the fact that since Jesus cannot raise His hand in blessing, since he is holding Menas, it is for Menas to make the gesture of benediction. Again, this is a perfect illustration of what it means to be a priest, or to be holy.

Unfortunately these are not always the same thing. Menas gives us not his blessing, but the blessing of Jesus, and he can only give it because Jesus holds him fast. Menas looks straight ahead. Jesus turns His eyes toward Menas, but not His head or His body. The Abbot is grey-haired, grey-bearded and balding. Jesus has thick, dark hair falling in waves to His shoulders, a small moustache, a slight beard, large brown eyes. It is almost an impassive face, yet I cannot but think there is the faintest suggestion of a smile. Jesus never does

smile in icons, but then He is never seen standing side by side with a humble follower and making clear how much He loves him.

The early Christians knew, as we do not, what it means to be crucified. They had seen for themselves the shocking indignity of it, the naked exposure, the agonizing death to the sound of hostile jeers. They accepted intellectually, theologically, that that was indeed the death by which Our Saviour redeemed us, but they could not bring themselves to depict it visually.

Yet how can one understand the wonder of the Resurrection without accepting the seriousness of the crucifixion? When finally, hesitantly, the crucifixion appears in art, Jesus is not shown realistically. He triumphs on the Cross, reigning from it, beautiful and kingly.

The crucifixion icon at Mt Sinai shows this royal Jesus. He stands erect on the cross bar onto which His feet are nailed, and holds His arms wide and straight in a gesture of loving acceptance. He is larger than Mary and John, who flank the Cross, far larger than the thieves crucified with Him, (one of whom has crumbled

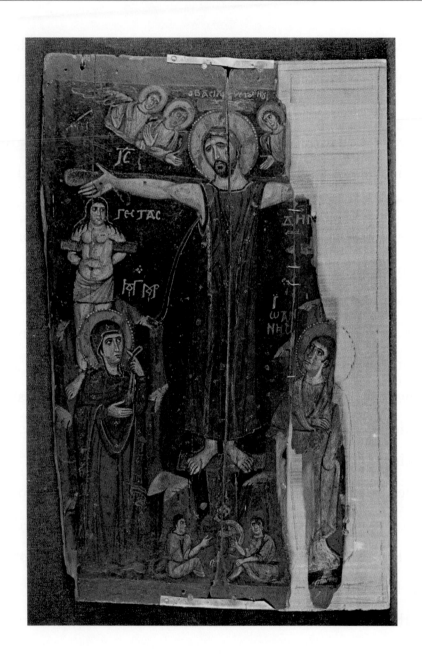

away in the course of the centuries), far larger than the angels who lean out from Heaven in wonderment, and very, very much larger than the minuscule Roman soldiers dicing for His garments at the foot of the Cross.

He is fully clad in a long priest–like garment, known as a collobium, which is adorned with gold. Yet there are here, for the first time in Christian art, indications of the bitter truth. His eyes are closed: this is a dead Jesus. Moreover, in His hair are what looks like three irregular stars, which apparently signify the crown of thorns. Very clearly from His side gush the two separate streams described by St John, water and blood. It is a subtle tribute to His dual nature, red blood for humanity, the pure crystal of water for divinity. Yet, despite those closed eyes, the face of Jesus is relatively inexpressive.

This, in fact, is a characteristic of icons. They are wary of dramatic emotions, and tend to avoid pain and sorrow. This is seen even more clearly in Mary and John. Western art shows a suffering Jesus and a suffering mother and disciple. Mary holds what looks like a long handkerchief to suggest grief, but the

eastern icon seeks to draw us out of our world of sorrow into that world where 'God will wipe away all tears from our eyes.' The executioners are seen as trivial, dwarfish creatures. What matters is the Lord in His power and self-sacrifice.

A minor point is the extraordinary depiction of the bad thief as female: notice the long hair and the bosoms. The poor creature seems to look rather balefully towards Jesus, a frightening contrast to His attentive mother.

There is one Resurrection scene at Mt Sinai, though part of it is missing. It shows Jesus meeting the two Marys after He rose from the tomb. Mary Magdalene kneels before Him stretching out her arms to embrace His feet. We know the story: He will say to her, 'noli me tangere', do not touch me, Mary, I have not yet ascended. The other Mary, who does not appear in the gospel Resurrection scenes, is Mary His mother, as an inscription on the icon makes clear. She too stretches out her arms, though both Marys have more or less expressionless faces.

Perhaps the icon painter, who was clearly not of the first rank, wishes to express the absoluteness of their amazement. Intense joy,

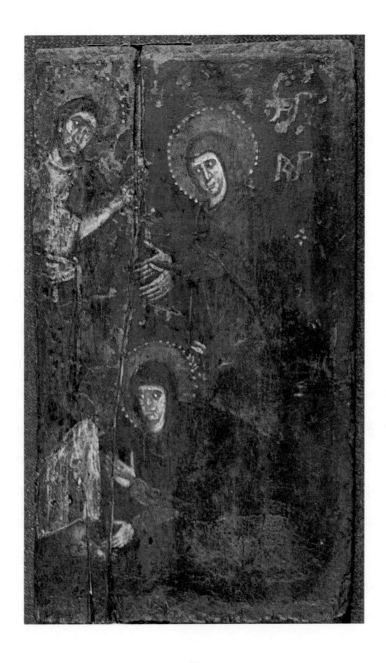

unexpected, overwhelming, can blot out all facial responses. What moves me about this icon is the figure of Jesus, incomplete though it is. The Risen Lord is so unlike all western depictions. There is no triumph here, no sublimity even. This is the Palestinian Jesus with His red-brown hair and dark beard, deeply aware of human frailty.

Yes, He has risen, but He is still unequivocally one of us. The newness of life which He experiences has not totally changed Him. Mary would have recognized at once the gentle, careworn features of her beloved Son. If this icon shows mingled joy and tension, the Ascension icon is also double-edged. Granted, the Apostles clustering around the Virgin are far from joyful. When Jesus was lifted up to ascend to His Father, forty days after His Resurrection, they felt bereft and deprived. The group of bewildered Apostles left behind, while angels bear Jesus skyward, was a familiar theme in Palestinian tradition. The essential point, though, was that they were clustered around Mary. She was there to invigorate them, to reassure them, to encourage them to carry on the apostolate to which her Son had called them.

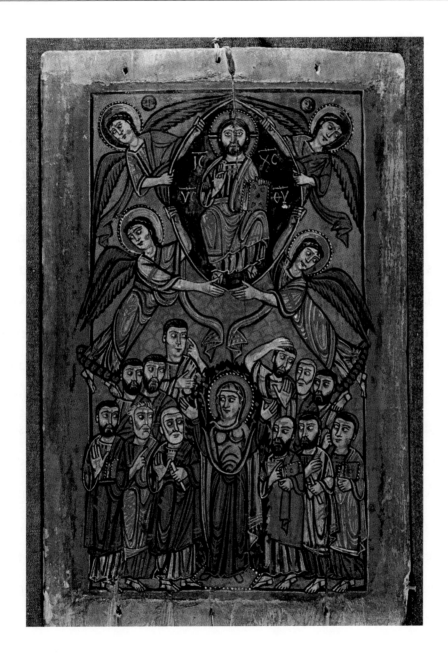

49

In this particular icon, the significance of Mary in the life of the Church is emphasized. According to the Scriptures, the Apostles are 'looking up to heaven.' Here, only one at the far right, (probably St John because he is both young and holding a gospel book) squints sideways and up; the others seem mostly to be looking at Mary, St Peter on her left holding a scroll, St Paul on her right holding his writings. The icon is blithely unconcerned with anachronisms. It does acknowledge legend, though. There is one Apostle rather out of place, and this must be St Thomas, who always comes late. Mary is standing on a small, bejewelled stool, to underline her spiritual stature. Behind her head are the leaves and red berries of a bush. The intention must be to recall the burning bush, which has always been a symbol of Mary's virginity, and this is a strong suggestion that the icon was painted specifically for the Mt Sinai Monastery.

Yet Mary's importance, and the intriguing interplay among the Apostles, does not detract from the subject of the icon, the Ascension of the Lord. The angels soar happily into space, their wings and their garments exceeding the bounds of the icon's frame. We have moved from time to eternity.

Jesus, in His mandorla, seated though without evidence of a throne, holding the scriptures and blessing, is gravely conscious of that eternity. In His physical form He has left us until the end of the world, when the sun and the moon that hang like bright buttons behind Him are destroyed: we will not see Him on earth again. But if Jesus is eternity, then Mary here stands for time. This is an unusually fleshly Mary, bosomy and feminine, with a look of ineffable joy.

There is in the Monastery another early icon of the Ascension, as there is one of the Crucifixion, and also one of Jesus standing. All three are gravely damaged, and by a neat coincidence, in each case the type of damage represents the perils to which ancient icons are exposed.

The Ascension image is striking but it is almost completely a reproduction. It had so decayed that there was nothing left except a vague Apostle or two, and a glory of diaphanous figures bearing aloft a mandorla. One of the monks, Fr Pachomios, repainted it, which makes it essentially a modern icon.

The Crucifixion icon has split into two. One narrow segment shows a grieving Mary. For the rest, on a larger segment, we can

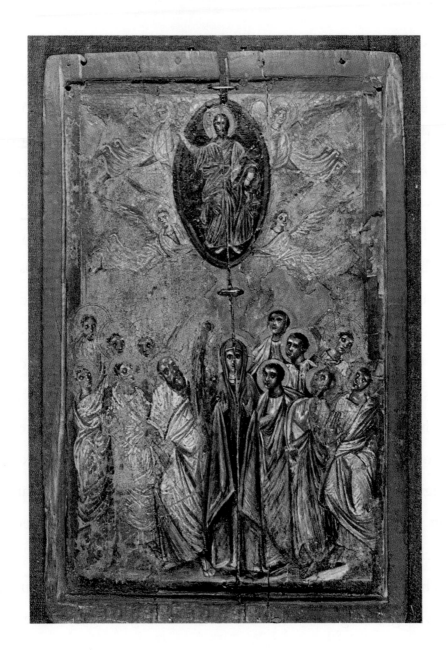

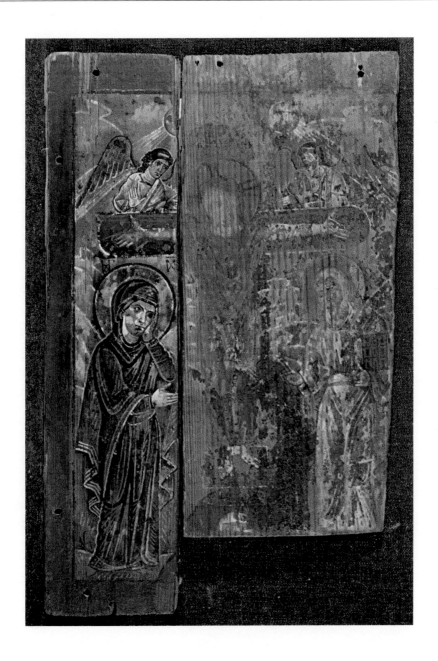

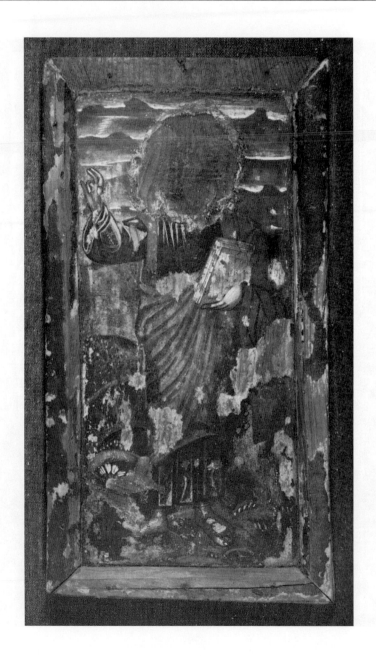

make out very little. Surprisingly, we can see that St John is shown as an old, white-haired, white-bearded man, but Jesus Himself is merely a blur. Yet even this blur is more readable than the pathetic remnant which is all that is left of the icon of Jesus Standing.

In this icon His face has been viciously scrubbed away, either by an unbeliever or an iconoclast visiting the Monastery. So whether as a result of the ravages of time, mistaken attempts at restoration or human malice, these icons are now spectral figures, there to remind us to be grateful for what is still preserved.

MARY

The greatest group of icons, of course, are the eight early images of the Virgin, five in Rome, one in Mt Sinai and one from Mt Sinai given to Kiev, and the extraordinary discovery quite recently of the one that is now in London. I went very gladly on pilgrimage to see these icons, and yet I was always conscious that it is icons of Jesus that are at the heart of Christianity. Clearly and profoundly though we love the Virgin, she can never be our primary concern. Too late I realized that I perhaps misread these icons. Did the early Christians, back there in the sixth, seventh and eighth centuries, see not an image of Madonna and Child, but rather an image of the Child, held in place by His mother? Might these icons be primarily images of Jesus, in the form in which He is seen at His most lovable? With one exception, each icon shows us a remarkable Holy Child.

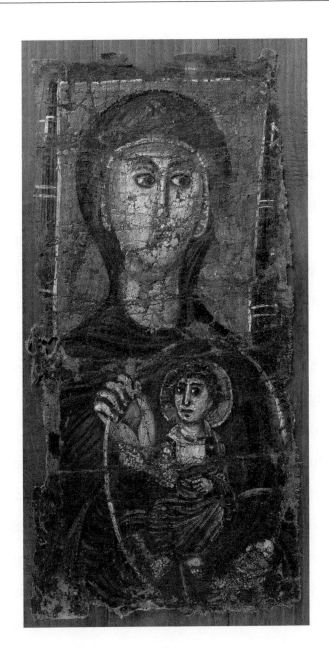

The whole world of pre-iconoclastic icons opened up to me when Dick Temple showed me the icon he had discovered. It had been sold in a French auction in Avignon, gravely discoloured, and only the experienced eyes of one who had loved icons for decades could see through to its potential. The grave and reticent Virgin, with her swan-like neck and averted gaze, is beautiful indeed, but what transfixes all who see this icon is the image of her Son. She holds Him in a transparent mandorla, and He gazes out at us with an expression of intensity and invitation that I have seen in no other portrait of Christ. He is not a prettified Christ Child. He has unruly red curls, enormous dark eyes, a pale set face, a strong adult mouth. He seems tense, driven, in need of our cooperation.

Once seen, this image is unforgettable. Urgency is no longer part of the post iconoclastic world. By the ninth century, and progressively thereafter, Christianity knew where it was, with of course all the dangers of drifting into complacency. There is no danger of complacency in these early centuries, though certainly not all the icons have the intensity that we see in the one in London.

The closest parallel is the icon in Kiev which was taken from Mt Sinai by a high-ranking Orthodox cleric, Archbishop Uspenskii. In this icon it is the Mother who is urgent, not the Child. The Child is radiantly beautiful, a golden Boy, reaching out in love to whoever comes. He gives Himself, with all the fearlessness of a Child who has never known danger or unkindness. But His mother knows danger and unkindness. She clasps her baby tightly to her bosom, looking away in the same direction as He does, but with fearful and beseeching eyes.

She knows that His nature is to love, yet mother-like she dreads the consequences of that sweet abandonment. We feel that if she could speak, she would plead with us not to wound her Child, not to drag Him into the insoluble problems of our violent world. We know how the story ends, and the set of her beautiful mouth, suggests that she knows it too.

The other Mt Sinai icon is one of the grandest images of Mary. Scholars feel almost certain that this was a gift from the Emperor Justinian: it is an Imperial icon. Mary is seated on a jewelled throne; she is guarded by warrior saints, St Theodore,

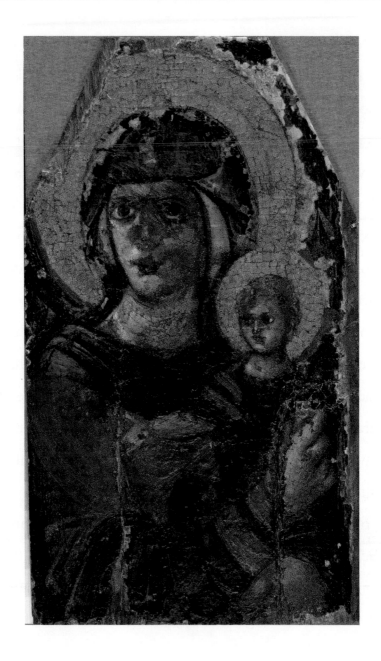

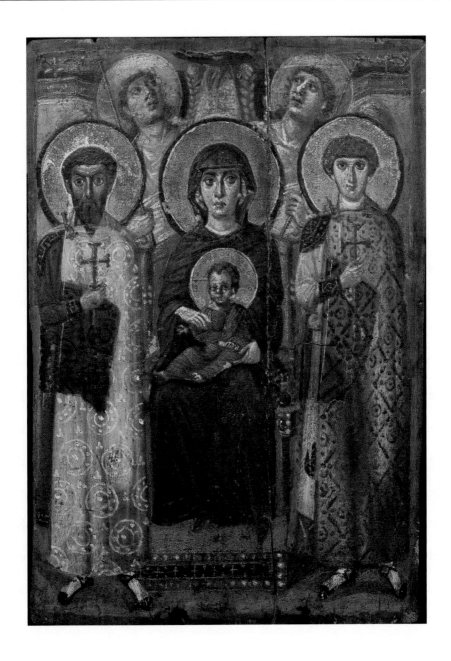

an older man, and St George (or maybe St Demetrius), who is youthful. Yet they are not so much guarding her, I have come to believe, as providing a guard of honour for the little Emperor. For the Child, Mary is His throne and her purpose is to present Him to us, just as the purpose of the warrior saints is to stand proudly in His presence, to do Him honour. It is an intricate icon with various levels of reality. Behind Mary's throne gleam the insubstantial figures of two great angels, and above them, framed in a triangle of gold, appears the Hand of God.

The angels look up at God, while the saints who are painted unrealistically – these are the images of saints, not their actualities – look impassively ahead. It is the little Jesus and His mother who interact with us, who are aware of us, in a way that neither angels nor saints can ever be. Mary looks to one side, slightly apprehensive. She has the same full and rosy mouth as the Kiev Madonna but there is no expression of intensity. The little Jesus, like the Kiev Child, is wholly unafraid, small, loving and lovable, and yet utterly a King. The Child in all these three icons draws the

heart so strongly that we can understand why this was a depiction of the Lord that enabled believers to believe they were loved.

All babies are by definition helpless. Without their parents they cannot survive. When we celebrate Christmas, we are celebrating this aspect of Christ's Humanity, His willingness to live our life to the full, including the physical powerlessness of its beginning.

The five Roman icons are all quite different, yet they share the significance of being 'temple icons'. They are mostly in churches, where they seem to have been, if not from the beginning about which we have no knowledge, but at least from very early on. In the sixth or seventh century they were already enshrined. Two are most gloriously enshrined. One, which is exceptionally large, has an obvious link to the Mt. Sinai Virgin. This is Madonna Della Clemenza in the great church of Santa Maria in Trastevere. The imagery is the same: Mary is an Empress on a throne, a much more splendid throne with a glorious scarlet cushion. The Mt Sinai Madonna is very simply dressed, while the Trastevere Madonna has a glittering crown and a magnificent robe. There are no saints flanking the throne, but there are two sublime angels

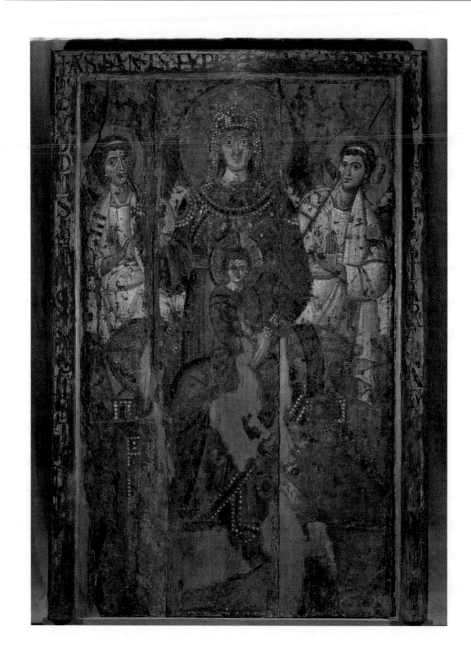

64

behind it, far more glorious (and human) than the ethereal angels of the Monastery. Those angels look up at the hand of God. These angels look out at us, yet with much the same gesture, the upraised hand of astonishment.

In case we are slow to understand the reason for their awe, there is an inscription still partly readable on the frame of the icon. It tells us that these are not mere angels, but archangels, 'princes of heaven', and they stand 'stupentes', stupefied, unable to understand the wonder of the birth of Jesus. It is a pity that the rest of the inscription is almost illegible, because it seems to be suggesting, not just that God has become man but that 'ipse factus est', that He made Himself man.

Perhaps in keeping with the theological depth that the icon sets before us, this is a rather older Jesus. Certainly He is a divine emperor, and His mother is His throne. Certainly His face is childish, pinked-cheeked, bright-eyed, yet He seems profoundly aware of what He is. Very aware of what He is, is the Pope who kneels before Him. We can barely make out his figure, which has almost completely disintegrated over time.

Historians think this is probably Pope John VII, and he represents all of us, all who turn humbly and trustingly to the Son of God. It is not altogether easy to translate 'clemenza' because clemency is not a word in common use. This icon is very much loved and prayed to and the title must have been given because of our perception that prayers, made through the icon to Jesus, were readily and graciously answered. The other icon that is housed in extraordinary splendour is in the Basilica of Santa Maria Maggiore.

It was in the seventeenth century that a special chapel was built, solely to display the icon. The Pauline Chapel, as it is called, has a baroque magnificence that must be seen to be believed. There are variegated marbles, golden angels, attendant statues: it soars aloft to a grand climax.

But the grand climax is not the little icon, which in some respects could be considered an anticlimax. Amidst all this grandeur, it is so small, so humble: there is simply a serious young woman, modestly dressed, holding in her arms a beautiful and serious child. Her hands are folded around Him as if in resignation: this is what it means to be Mother of God. The

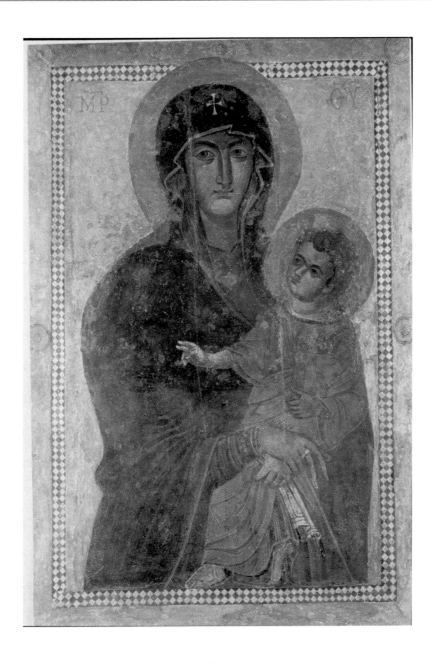

Child leans sideways holding a book and raising His small hand in blessing, just as we see in the great Pantocrator images. This icon too is dearly loved, and has a title, 'Salus Populi Romani', the Salvation of the Roman People. This might be considered rather parochial, since Christ is the salvation of all people, but then, this is a parish, and Santa Maria Maggiore is a parish church.

The third icon is also in a parish church, but not on display. The church is the Pantheon, the first of the ancient Roman monuments handed over for Christian use. In fact it is the only Roman monument so transformed. It is an engineering marvel, and was built in the year 27 before the birth of Christ. The ancient icon is preserved in reverent secrecy under the Pantheon. In its bowels are subterranean passages which contain the sacristy, where the priest robes for Mass, and a small altar.

There one can find this battered but still very legible icon of the small Jesus held by His mother. There is a gleam of gold about the hands, and perhaps the faces. The pagans painted gold on the statues of the god of healing, Aesculaepius and its lingering

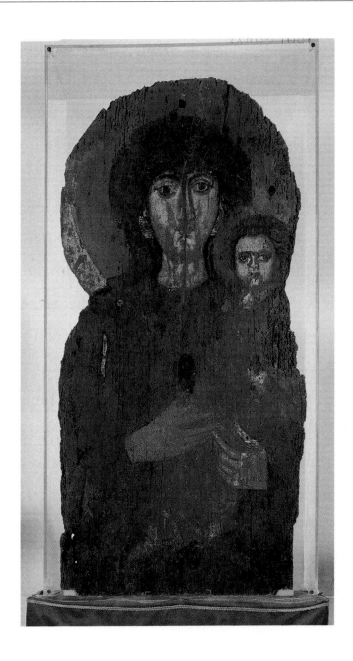

presence here indicates that the sixth century Christian thought this was rather a good idea. Jesus was health in itself, and His mother holds Him out to heal us. Here again we have a very serious Child Jesus, with a round, plain, wondering face. He seems aware only of the mystery of what He is.

It is a wonderful experience to encounter this mystery in the shadowy recesses of this great church. We seem to be in the depths of the earth, not only weighed down by masonry, but by an incredible weight of believers throughout the ages. And beyond that is the weight of contemporary Rome, noisy and violent, like every great city.

The last of the two great Roman icons are no longer in their original churches, their 'temples'. One, however, is almost in the same place. Santa Maria Antiqua was one of the most ancient of Roman churches, overlooking the Roman Forum. Italy is subject to the occasional earthquake, and when this ancient church collapsed the icon was saved and installed in its replacement, Santa Maria Nova. Somehow this church has received a new dedication to the comparatively modern Santa Francesca Romana (for some

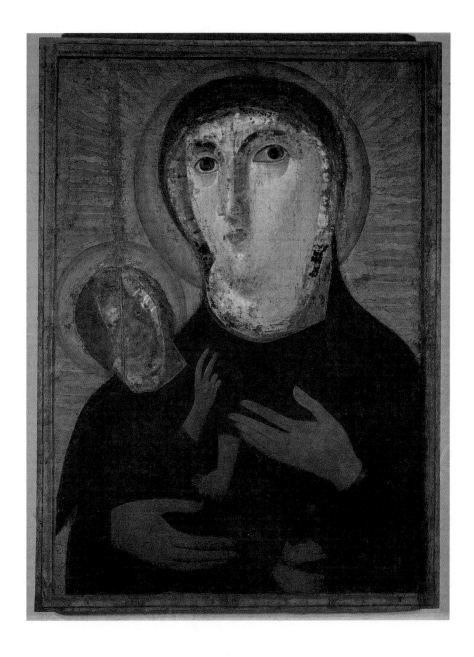

strange reason the patron saint of Roman taxi drivers). The church is only open on a Sunday, and the icon is kept in the very small Benedictine Monastery which adjoins it. The handful of monks who live there revere the icon in their tiny chapel.

Of all the icons, this is the most fascinating and the most damaged. For years it was overpainted not once, but twice, and when these secondary icons were removed, there was still damage to the sixth century original. Our Lady's head does not fit properly on her body, and the Child Jesus is only dimly present. It is a very large icon, and of all the icons in this book, the one that most needs to be seen. Mary has the most delicate of complexions, rose-petal and otherworldly. She glimmers before us, with a luminous beauty.

Our human vocabulary falls short here. This is precisely what an icon strives to be, an intimation of the truth of heaven into which we are drawn as we contemplate. Yet once again, if we could have seen the image undamaged as it was in the sixth century, we might have seen that this too is an image of the Child, rather than of the mother. This Child, unlike the others, looks not at us but at His

mother. As far as we can see through the ravages of time, this is once again an older Jesus, not a baby yet still a child.

Significantly, it is not us He is blessing, but His mother. Jesus is the source of all grace, and however holy His mother is, she is only holy because of her closeness to Jesus. In the icon, one long, slender hand points to Jesus as He blesses her, as if to say without explanation that she is what she is because of her Son.

The fifth of the Roman icons is the anomaly. This is the one icon which shows Mary alone. Some people think it is the loveliest of all these icons. She is shown as an exquisite, young Roman woman, something which we will never see in the post-iconoclastic icon. She is completely woman, rounded and rosy, yet it is abundantly clear that her whole longing is set on God. This could even be Mary before the birth of Christ, a doe-eyed village maiden. Yet although Christ is not seen, He is very present.

She stretches out longing hands towards her unseen Saviour, her face reflecting the deep import of her perpetual prayer. This is the Virgin of San Sisto, who has been venerated in several ancient churches, but nearly always cared for by nuns, and

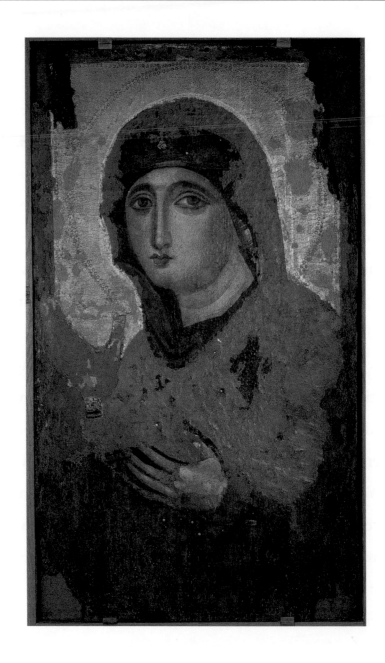

her final home is in a monastery of contemplative Dominican Sisters.

Once again, this icon has been venerated for centuries as an icon of healing. Her hands are held out in prayer, not shoulder-high, as in an the ancient orants, but at waist level and stretching to the left. They are sometimes covered with golden and bejewelled gloves. As with the icon at the Pantheon, this is an ancient sign of the comfort and support those in need found in her. She has a golden background, one can barely see her halo, and there is a golden sweetness and fullness that distinguishes the icon. Hers is a longing face, one aware of sorrow, and yet the main impression that one takes away is that of serenity.

The Monastery of St Catherine has two other very early icons of Our Lady, but both are so damaged that they are rarely seen. One is a Virgin of intercession, fragmented, overpainted, her face disfigured by breaks and paint loss. The long inscription beside her is a reconstruction. Yet through these obscuring clouds, we can still see how lovely the Virgin's face is, how tender and sensitive

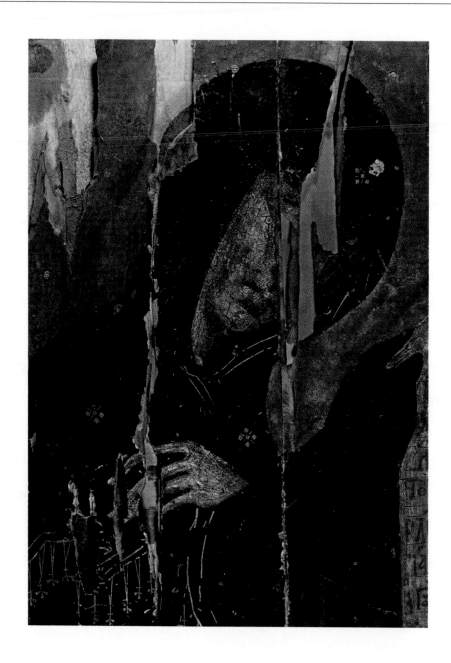

her mouth. Like the Roman Virgin of San Sisto, she holds no Child, but makes us fully conscious of the presence of the One to whom she prays. Scholars think this might be the remnant of a diptych, paired with an image of Christ. Even in her wrecked condition, she draws us to her Son.

Weitzmann thinks this Virgin may have come from Constantinople because of its subtlety, whereas he considers the other icon of the Virgin, that is in the same damaged condition, to be of Palestinian origin. Tragically, all the damage is in the centre. Mary is holding a mandorla that encloses her infant Son, just as she does in the London icon, which too is considered of Palestinian or Egyptian origin. But the icon is blackened as though it once was endangered by fire. All the centre has been burnt away, so there is a mandorla but no little Jesus, and a Mary of whom only an eye survives. The clear, strong outlines do remind us of Coptic art – there are rather similar icons at Bawit – but even with only an eye surviving, this icon can still touch us. It survives, despite all that time and accident can do.

Both at Mt Sinai and at Rome, there are splendid icons with

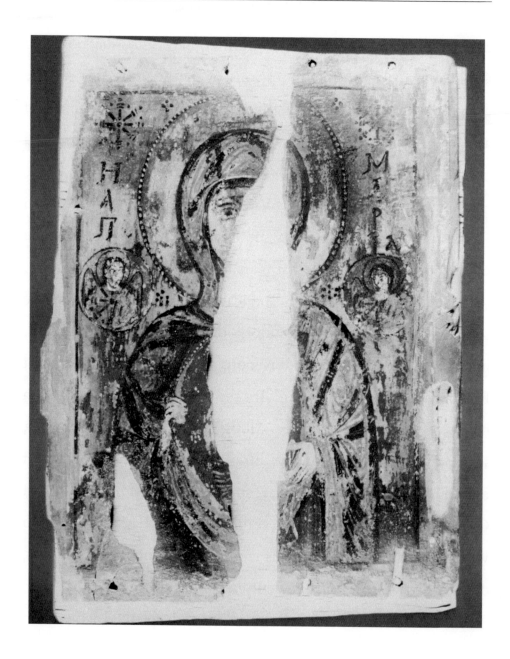

adoring angels in the background. This poor little diminished icon has two small angel medallions, rubbed and burnt like the Child and the Virgin, but surviving. Mt Sinai has one final Virgin enthroned with Child. Here it is more the intention that we honour than the achievement. Mary is seated, but her child seems to be standing. He is suspended, held aloft by His mother with only His small feet touching her knees. He has a strange, eager little face, and Mary's face too is unusual. Neither are beautiful but they have a certain piquancy. Mary's face seems to express a sort of happy tension that we see in no other Madonna. As in the more resplendent Madonnas in Rome, she sits on a brightly-patterned cushion, yet here neither she nor her Child have a sense of physicality. It is more like a theological sketch of the vitality of Jesus, and the eagerness of His mother to share Him with the world, than a true human, if divine, mother and Child.

After the crucifixion, the most common religious image in the West is that of the Nativity. Mt Sinai has one early Nativity, and scholars see several parallels with the earliest Christian tradition.

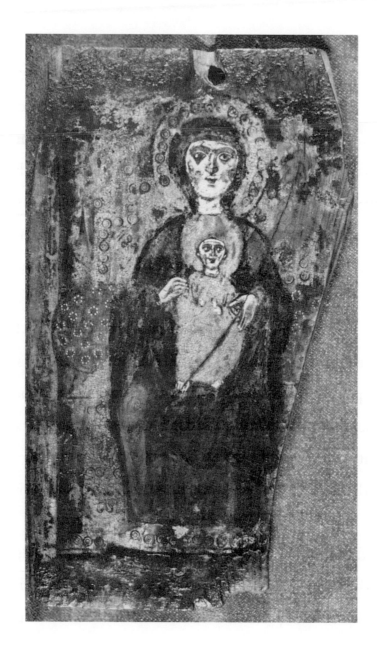

Mary is central, on a long, sausage-shaped mattress, highly decorated and tilted diagonally to allow her to recline rather than lie down. She wears an expression of a most profound and secret joy. Above her we can dimly make out, though flaking and fading, the ox and the ass looking prayerfully into a flattened niche in which lies the swaddled Infant. Two young shepherds reach out wondering hands towards him. Beneath Mary – and this part of the icon is better preserved – there sits on the right a puzzled Joseph. Somehow in the cave he has found a stool. He props his chin on his elbow and marvels at the mysteries of God. To his left – an image that was dear to the Eastern Church, but appears infrequently in the West – Jesus is seen again, being bathed by the two midwives.

There is a legend connected with the midwives, that one doubted the virginity of Mary and found her arm had withered away. When she bathed the Child, her fault suddenly became clear to her, she repented and her arm was restored. Nothing in this little tableau recalls this bizarre legend, except perhaps the blissful expression on the midwives' faces. This is an icon that

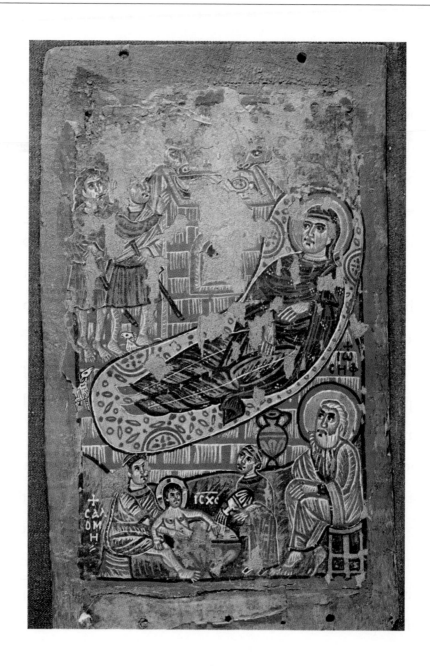

moves through time, because the tiny Jesus in His crib at the top is much younger than the Jesus who is being bathed and is able (divine precocity?) to steady Himself on the rim of the basin.

A fairly recent discovery of three small round icons hidden within a jar is not easily classified. The icons are all tondos with a bottom attachment which suggests that they may have fitted into some larger sacred object. Some scholars think they were terminals for staffs, others that they decorated a larger icon or even a piece of furniture.

One of these icons, these small round icons, which may even be fifth century, is of the Virgin. She looks straight ahead, serious, thoughtful, beautiful; her eyes are large and filled with wonder. Whatever the origin or use of this icon, there seems to be agreement that it comes from the Coptic world. The Coptic Mary looks self-contained and thoughtful: we remember that these icons have a desert background. A niche at the Monastery at Bawit shows her among the Apostles.

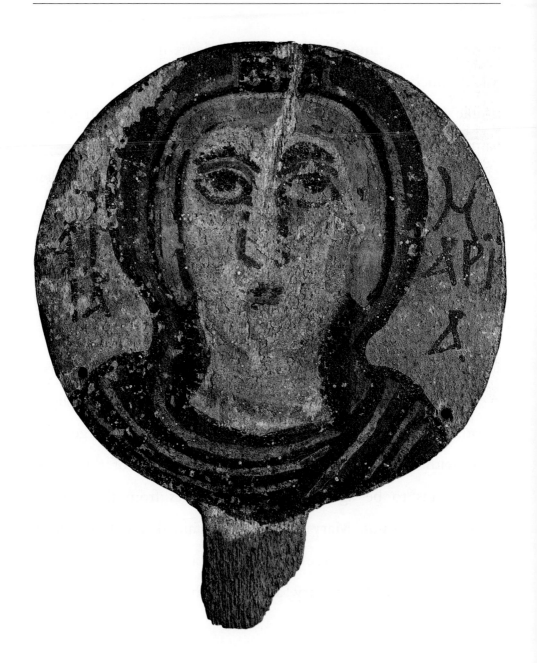

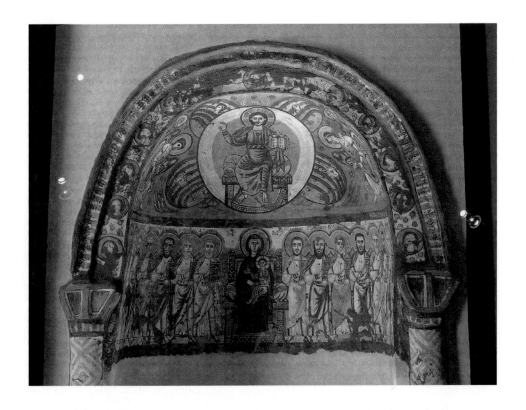

She sits on the usual throne on a long, round cushion, and she holds an alert and active little Jesus. He is a small, elongated figure, clutching the scroll of the law and with His other hand, perhaps not so much blessing the Apostles as drawing them to our notice. The Apostles themselves have the happy self-confidence of those who know God is pleased with them.

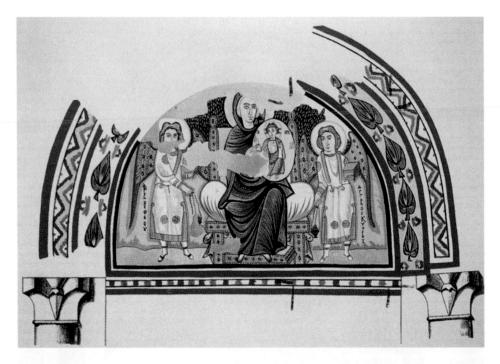

Another icon from the same monastery shows Mary holding a mandorla, which could almost be an icon of her Son. He does not sit upon her knee but seems a vivid, albeit two-dimensional image, on the solid plaque of the mandorla that she holds up before us. This Mary, like others we have seen (same throne, same cushion), has angels to either side, but there is an even stronger sense of the only reality being the icon within the icon, the image of Jesus.

THE SAINTS (AND THE OCCASIONAL ANGEL)

Fundamental to Christianity is the act of bearing witness. Only occasionally does this demand talking about our faith. Normally, it is the responsibility to show in our lives how our faith has transformed us. Truthfulness, kindness, lack of self-importance, acceptance of responsibility: these are meant to show the non-Christian the freedom and happiness of belief.

In the early centuries, it was this goodness, in the way one lived, that led to a climax of goodness in the way one died. Life and death 'bore witness.' The word for witness was 'martyr', and the early Christians drew great inspiration from their holy martyrs. They celebrated the Eucharist in the places where they were buried, they carried away the blood stained soil, they revered the garments and even the bones of these true followers of Jesus.

Relics were meant to draw us to an understanding of what bearing witness meant, and to encourage us to love as fervently as those who had laid down their lives.

Icons may well have developed from this sense of needing encouragement and focus. Pictures of the saints could be as inspirational as physical relics. The pictures, the icons, were not meant to be portraits. The only exception seems to be that of St Peter and St Paul, who from the earliest ages seemed to have a recognizable iconography. Peter is white-haired, white-bearded and stocky, Paul is slighter, balding and dark.

There is a remarkable fifth century Roman mosaic of St Peter in St Paolo fuori le Mura in Rome, which shows the traditional white-haired, low-browed St Peter, but with a vividness and power that contradicts popular modern readings of the Gospels.

There St Peter is seen as lightweight, impetuous and foolhardy, all too often revealing himself as flawed. This is a possible reading of the Gospels, but this is not the Peter who, alone among the Apostles, saw Christ as what He was: 'my Lord and my God'.

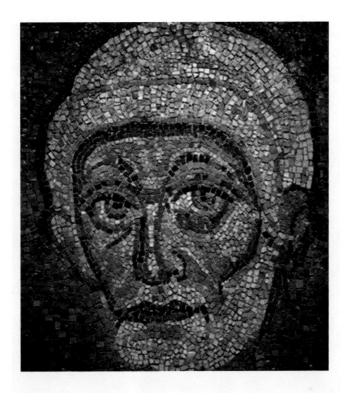

This appealing human St Peter is not the charismatic leader who led the first disciples out of the imbroglio of Judaic bewilderment into the centrality of Rome, and there was crucified, witness to his beliefs.

The Sinai icon is almost life size, a half-figure of a very recognizable St Peter. In his right hand, though they are barely recognizable, he carries the keys, which are St Peter's great

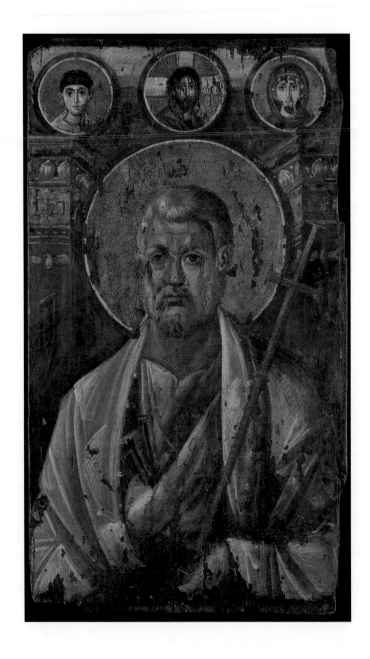

attribute in art. Jesus bestowed on Peter, because of his faith, that rock-like fundamental Faith upon which the Church would be founded 'the keys to the Kingdom of Heaven'. In his other hand, Peter holds the Cross on which he too, following his Master, would be crucified.

It is not these attributes that make this a great icon. Rather, it is the sense of a mature, wise human being, a man who has understood the triviality which comprises much of our existence, and looks beyond it to eternity. This is the strong, self-sacrificing leader of humanity, Peter, either as he was or as he wished to be.

Above the image, in the position where the pagan image would show medallions of the Emperor and the Imperial family, are the medallions of what are significant to St Peter, non-Imperial. Central is the image of Jesus, the Semitic Jesus, profoundly human although it is damaged. On the right is Mary and on the left a youth who is probably John the Baptist, or even John the Evangelist, either promoted beyond their intrinsic significance by the need to balance the central medallion of Jesus. This Peter is in no way a well-meaning fisherman. He is a spiritual aristocrat, a

leader of the Church, able and willing to meditate on the teaching of his Lord and draw out its significance. The weight of authority that the icon carries is unique, and I find it peculiarly touching that the image of Christ, embedded above it, is not of the majestic classical Pantocrator but the human and vulnerable Semitic Jesus.

Another icon with a poignant medallion of the Semitic Jesus is the extraordinary John the Baptist, now at Kiev. This is a sixth century icon à la Van Gogh. There is nothing like it in iconic art, for its untidy passion and its impressionistic sense of a devotion to God that transcends time. Weitzmann thinks it might even be fifth century. It has an interior weight that makes it strangely memorable. John the Baptist was the last of the prophets, the final proclamation of the Old Testament which welcomed Jesus and the newness of His revelation. It is a blurred and battered icon, but the heavy, prophetic face looms out at us with unquestionable authority, but the authority is not that of his own surrender to God, but of his acceptance of Jesus shown to his left and, in his wake and testimony to his manhood, the image of Mary. There is a holy violence and energy about this

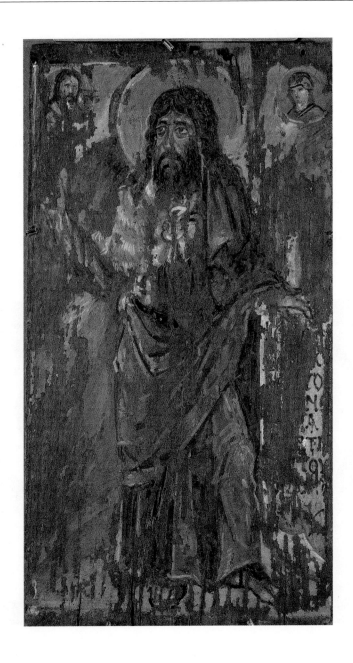

icon that makes it a unique testimony to what it means to be aware of the truth of Jesus.

Also in Kiev, brought there in the mid nineteenth century, is the image of St Sergius and St Bacchus. We would expect to find more martyrs among the early icons. On the whole though, they depict men, and to a lesser extent women who bore witness by the integrity of their lives, rather than their deaths.

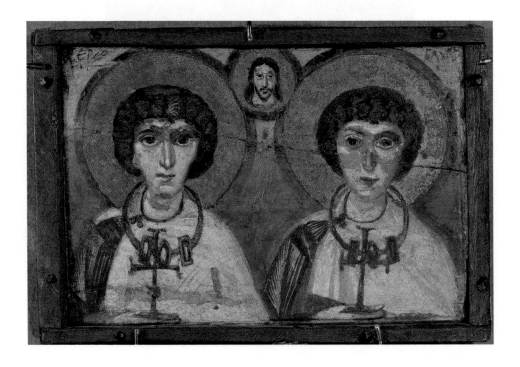

However, St Peter was martyred and so was John the Baptist. Since Sergius and Bacchus, according to their hagiography, were officers in the army of Maximian who ruled from 286 to 305, the Emperor thought well of them until he discovered that both were Christians. The icon shows them in their official court attire and not in their military uniform, wearing the jewelled torques of authority around their necks, to signify their status.

Both were violently put to death for their faith, and were greatly revered in the Byzantine Empire. This is a touching instance of double martyrs, friends who marched together into death, proclaiming their faith. We can see that each is aware of and supported by his friend: they turn slightly toward each other and they are shown as different, Bacchus being more fleshly than the more austere Sergius.

It was always important in Christianity to be supported by fellow-believers, and the deaths of two young and successful men at the beginning of the fourth century emphasizes that. Once again the centre of the icon is a small medallion of a very human

Jesus. He it was who dominated their lives and held them steadfast amidst unimaginable pain and sorrow.

The monks at Mt Sinai gave a third icon to Kiev, where the museum has been most commendably faithful to its responsibility. These four early icons reside in a separate chapel-like space. The third icon is painted blue, the iconic symbol of heaven, and it displays with reverence the early icon of the Virgin (the passionate, fearful Mary), the impressionistic St John the Baptist, the prayerful, peaceful St Sergius and St Bacchus, the extraordinary St Platon and an anonymous virgin martyr. It is very annoying for historians not to know who this virgin martyr is. Certainly, in post-iconoclastic art, there was a firm belief that one could not pray to a saint unless one knew who he or she was. Names were clearly inscribed. In this case, the icon is not in the best condition.

The inscription announces that the male is St Platon, who must be the wealthy young man who was martyred about 306. There were other Platons, apparently rather a common Christian name, but the earliness of the icon confines us to the very early centuries.

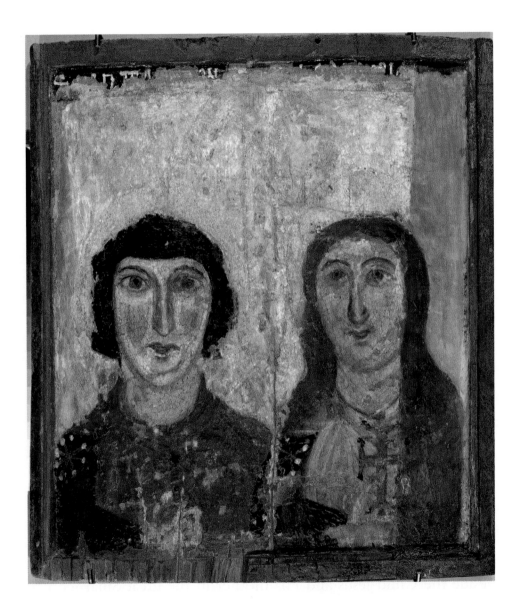

When saints are paired, as they are here, there are usually two explanations. One is that the other saint, in this case a woman, plays a part in the story. The other explanation is that it could be pure coincidence that both saints are commemorated on the same day, in this case July 22. But St Platon endures only as a name, a martyr whose inspiration lit up the East for centuries after his death.

Without a story, without even a name, we cannot identify his female companion. These seem to us rather crude icons, and the woman certainly has a rather pumpkin-like face. They may be examples of the kind of simple images that the faithful clung to in their hours of silent prayer, not painted by great artists, yet commemorating lives of holy dedication. What always strikes me about St Platon and his companion is their ordinariness and their happiness. These are not great heroes: these are us, plain and unimpressive, but called to bear witness to God's love.

We have already seen St Theodore, the warrior saint, on duty beside the Child Jesus and His mother in the great Sinai icon of the Virgin and Child. Here he appears again, in golden armour,

richly decorated to indicate his high military office. (He is known as St Theodore the General). Because he usually appears with St George, (or that other dragon slayer, the youthful St Demetrios), there is a suggestion that this might be half of a diptych. What I find impressive, though, are those great burning eyes, and the air of barely contained emotion. This is St Theodore seen less as a warrior than as a man of intense Christian faith.

Compare him to the Coptic icon, found in the Monastery of St Apollo, in Bawit. Again, we only have half of a diptych, and there is a complication in that the original image showed a monk, St Phib. About fifty years

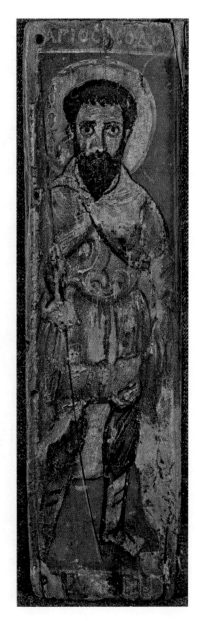

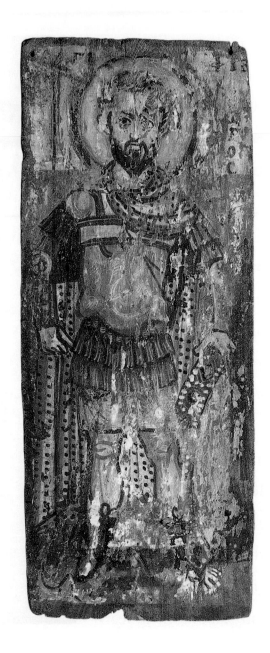

later, though still in the sixth century, the little known and possibly uninteresting St Phib was overpainted by this image of St Theodore the General. This is not the passionate searcher after God, this is definitely a warrior. The Bawit St Theodore stands at ease in his armour, well aware of its imperial significance and prepared to slay any satanic dragons that present themselves. Mt Sinai's St Theodore battles within his own spirit; Bawit's St Theodore battles an external foe.

Although the central icon is lost, the Monastery of Mt. Sinai still treasures the two panels that were originally the wings of a triptych. Each panel shows two saints neatly separated from each other by frames. When the wings are flat, as they are now, we can see that the juxtaposition is far from accidental. The upper levels show St Paul in one wing and St Peter in the other.

They hardly need their identifying inscriptions, as both are shown in their traditional form. St Peter is stocky, white-haired, white-bearded, carrying the scroll of authority but also, very firmly, two keys on a large key-ring. He is dressed in blue with a carmine cloak. St Paul, again, is as we would expect, slighter of

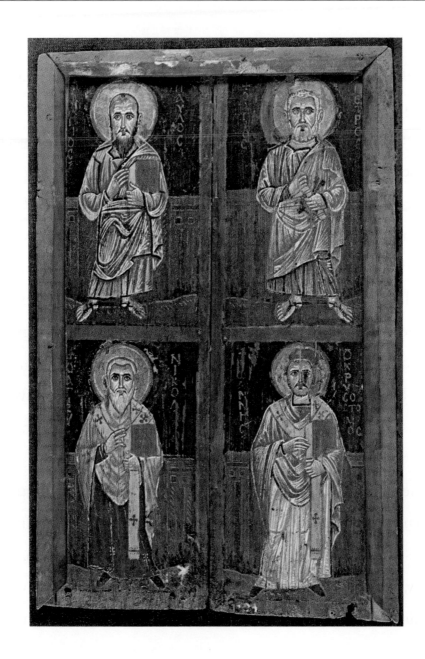

build, balding and black-haired, carrying the book of the scrip-
tures. He has a carmine robe and a blue cloak.

Below them are two saints who were highly revered in the early
church. Beneath St Peter is St John Chrysostom. Chrysostom
translates as 'golden mouth' and this St John (about 349–407),
was perhaps the greatest orator of the early church. His fluency
in writing as well as in speaking was greatly admired and was, in
fact, highly necessary. After some years as a hermit, he became the
Bishop of Constantinople, but he was continually at loggerheads
with the Emperor, who had a soft spot for the Arians, whereas St
John Chrysostom saw their danger.

Twice at least, then, he was sent into exile, but he felt that
his writings supported his diocese when he could no longer
be present. Indeed, they supported the whole church. An early
writer said of his works, 'they crossed the whole globe like
flashes of lightening.' In the icon, all that blazing charisma, which
also, of course, distinguished St Paul – is subdued to a peaceful
dignity.

The fourth saint, St Nicholas (270–346), was destined to

become the most popular of all saints in the Orthodox Church. The Western Church is fond of him too: he is the Klaas, the Dutch form of his name, who is remembered as Santa Claus. There are many touching legends of his life, but since most of them were only written down in the tenth century, they would not have come to mind when the sixth- or seventh-century monks venerated this icon. As is typical of icons, all four saints look straight-ahead, fully frontal. Their large eyes transfix us, drawing us out of our earth into their heaven.

Also on the wing of a triptych, though this time only one wing survives, are Saints Athanasius and Basil. They are only half size, and Athanasius has a large square missing from his upper face. We can see enough of him, though, to receive the impression of earnestness, and to be touched by the firmness with which he holds the gospel book. This is a seventh century icon, and Sotiriou, who was the first scholar to discover the treasures of Mt. Sinai, is convinced that this is not the great St Athanasius of Alexandria (about 300–373), hammer of the heretics and writer of the Festal pastoral letters which we have already met. Sotiriou

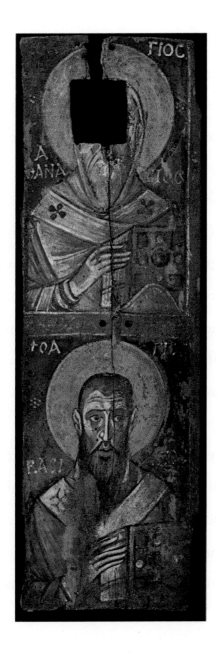

thinks this was an early abbot of Sinai, and he is not dressed as a Bishop but as a monk. It is impossible to know whether the monks at the monastery revered their late abbot in perpetuity, or whether as time passed and memory faded, he became conflated with his great namesake.

Beneath him, though, is an unmistakable Father of the Church, St Basil the Great (330–379). He was Archbishop of Caesarea, in those days a post of essential importance. It was his longing for the truth that established the Faith through much of the Middle East. Yet perhaps he is even more significant for what he gave the monks: a rule of life. He gathered together scattered hermits and gave them a monastic rule, as balanced and as wise as that of St Benedict.

Over a century later it was St Benedict who established Western monasticism, just as St Basil had established the monks of the East. The icon, which is rather unusual, shows St Basil's lips as slightly apart, as though he is silently preaching to his followers. Both saints emanate a powerful sense of concentrated prayerfulness.

Another triptych, of which only one wing survives, show two half lengths of St Chariton and St Theodosius. Both saints hold up their hands in prayer, both look sharply and intently to the right. Chariton (about 274–?) was a saintly monk from the city of Iconium. He was arrested for his faith and tortured, but for some reason he was exiled and not executed. He went to Palestine where he established several monasteries in the desert of Judea. Chariton was evidently the kind of man whose love of God is so visibly intense that he is not easily forgotten.

St Theodosius, among other saints of this name, is surely the monk Theodosius (423–529). He also lived in Palestine, and also impressed all who met him as a man who followed very closely the example of Christ. Notice that he died at the age of 106, apparently suffering many years from an agonizing illness, which he would not pray to have cured. He said he needed the penance of it. Both these saints were dearly loved by the monks who chose them as heads of their communities, but the impression given here is one of great spiritual strength and intensity rather than of gentleness and charm.

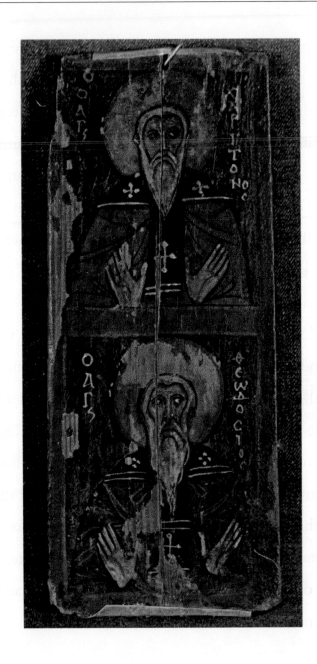

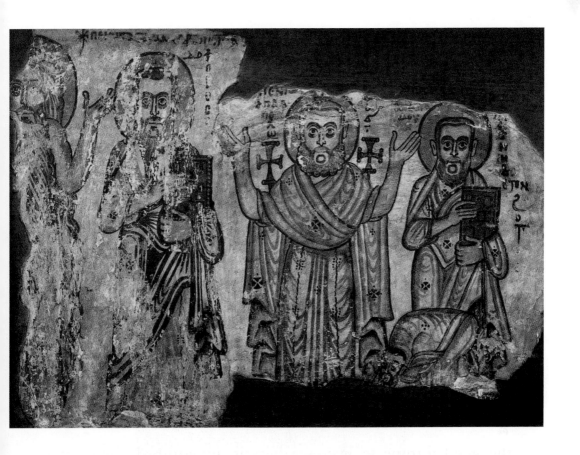

When it comes to charm, I sometimes think it is slightly more of a Coptic characteristic. A niche in the monastery of St Jeremiah, at Saqqara in Egypt, has a rather fragmented image of four bearded saints, and a small monk bent low in prayer before St Apollo.

Apollo lifts up his arms in the gesture of prayer, and the adoring monk, on the walls of whose cell this icon must have been painted, is associating himself with the glory that St Apollo gives to God. Apollo (316–395) was a famous Egyptian saint. He became a hermit in childhood, and lived for forty years in the solitude of the desert. But, as is often the sad fate of holy hermits, he attracted so many followers that in the end he bowed to the will of God and established a monastery. This is said to have sheltered five hundred monks.

The man to his left has a label reading, 'Macarius, bearer of the Spirit' (about 300–390), also a famous hermit-become-abbot. The interesting figure at the far left, with his very long hair and beard, is St Onuphrius, who died around 400. He had the good fortune to live as a hermit, undisturbed, for seventy years. This privacy was very necessary, since he apparently wore no clothes at all and was 'dressed' only in his hair with a small, modest loincloth of leaves. The monk who commissioned this line of saints was careful to write their names, but the inscriptions are beginning to crumble, and it is only an early

III

photograph that tells us the fourth figure was St Pamun. He is one of the many early saints of whom we know absolutely nothing.

Although one would not guess it from these early icons, there were also monasteries of nuns in the desert, and of course both monks and nuns venerated female saints. The only icon of a woman, not counting the Virgin Mary, that survives from these early centuries, is that of St Irene.

She was a fourth century Persian martyr, or rather the legend says that she underwent martyrdom but survived. King Licinius, who incidentally was her father, had her thrown under the hooves of wild horses, to be trampled to death. In one of those miraculous reversals of fortune that adorn these legends, the horses stayed still and one of them charged the wicked Licinius tearing off his right hand.

The horse was all set to trample the King to death, but his compassionate daughter demanded that she should be untied, and then gently led the horse away and restored her father's hand. Needless to say, the King, the Queen and the whole

city immediately turned Christian, and St Irene led a long life, converting, healing, and preaching.

Because she had so willingly given herself to martyrdom, though it did not happen, she holds in her hand the black cross of a martyr. She also holds a handkerchief, perhaps to indicate that she will mop up our tears and offer comfort in times of distress. At her feet is a young man with black hair, bending low, and he is clearly the donor of the icon. St Irene is by no means a glamorous saint. She is small, stocky, and very resolute. She has the clear direct gaze and the firm lips of one who is quite capable of staring down a herd of wild horses. This is what the donor wanted and needed, a protector, herself protected by her faith in Jesus.

There is an extraordinary icon from Fayoum, in Egypt, near to the city of Crocodilopolis (wonderful name). Fayoum is of course the great site of the late Egyptian mummy portraits, with their outstanding sense of living reality. This icon too has a sense of living reality, yet it is rather difficult to read. The inscription says clearly: 'our Father Mark, the Evangelist'.

The Coptic Church points out that St Peter went to Rome and

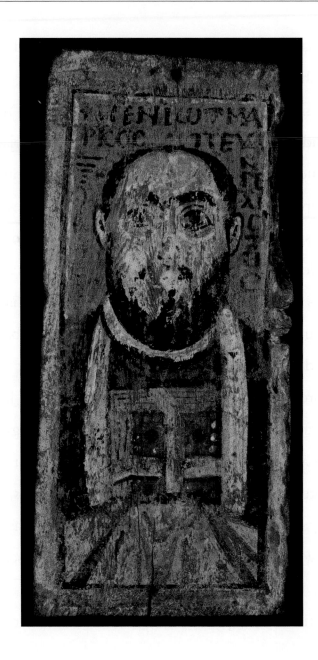

is the great Catholic evangelist. Their evangelist, however, is the great biblical St Mark, in whom they rightfully take pride.

Yet the icon does not have the nimbus, the round halo, that denotes a saint. Rather, if there is any halo at all, it is square, the sign of someone still alive. He is dressed as a Bishop in clerical costume, and holds the gospel book. Out of reverence, he holds it covered with a cloth, as you can see at the base of the icon. So: is this an icon of St Mark? Or, is it an icon of a sixth century Egyptian bishop, so compelling in his face that his people saw him as St Mark-come-again? This full, fleshed face, nearly as broad as it is long, might not strike us as overwhelmingly spiritual. Yet this heavy, thick-featured countenance is very like the portrait of the Abbot Longinus, that we find at the corner of the great Sinai mosaic of the Transfiguration.

The scene is ringed by small images of the prophets and apostles, and at the far right corner the artist depicted the contemporary abbot. He is not shown as a saint, but he is shown as the same heavy-featured emphatic personality. One would presume that this Bishop seemed to his people to be following St Mark so

closely in practice and precept that his portrait could be used to represent the Saint.

There is the same heaviness of feature in one of the rare anonymous portraits of a saint. This might even be fifth century, and is clearly connected to the mummy portraits, commemorating

 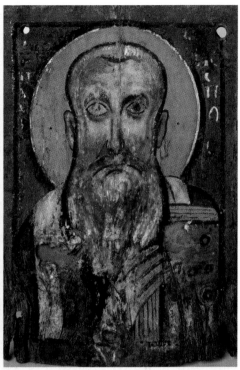

a holy man who recently died. The impression, even more than in that of St Mark, is the certainty and intensity that distinguishes a saint.

Another puzzling portrait from Fayoum, which some scholars think might even be from the fourth century, shows a nameless saint. He has a square halo which suggests that it was painted while the holy man was still alive. The large, staring eyes are fixed

on heaven. Whoever we are contemplating, nameless though he is, was somebody whose closeness to God impelled those who knew him to commission this icon.

This young saint, whose name is forgotten, can be compared to the contemporary portrait of Bishop Abraham of Bawit.

The inscription reads, 'our Father Abraham, the Bishop'. The circular halo makes it clear that this is a saint, while the inscription makes it equally clear that this is the Abbot or Bishop of Bawit. It is a wonderful face, quite unprepossessing, like an elongated peanut, with a great sickle of a downturned mouth, protuberant ears and a scanty beard. He clutches the scriptures, and looks sternly at the viewers.

Surely this is a portrait, in the sense that the icons of Christ, Mary and the Apostles are not? Yet it seems to be a portrait painted in the conviction that Abraham was a saint, and it seeks to show that what he is, what he means, and how he appears is of lesser importance.

There are also some striking icons of angels. With the icon of

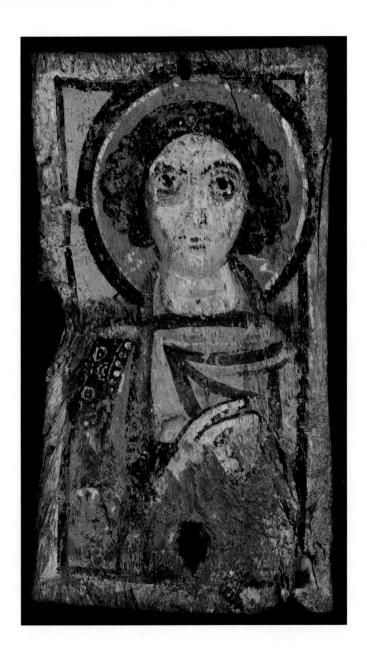

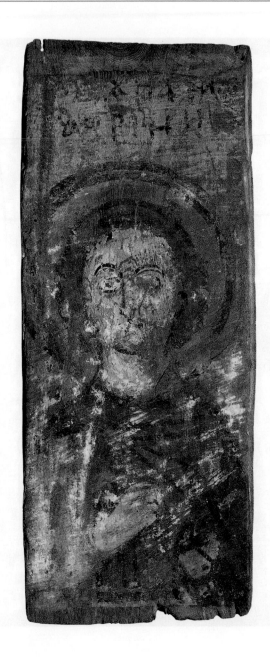

St Mark at Fayoum, (near Crocodilopolis) was also found an icon of an archangel. Quite unlike the burly, physical St Mark, here we have an aristocratic youth, with a ribbon in his hair, whose clothing identifies him as an officer. But the halo, and little stubs of wings on his shoulders suggest that this is an archangel, one hand graciously raised in blessing.

There are two other interesting Coptic archangels. One comes from the Monastery of Bawit, and is painted on the back of the icon of St Theodore. An inscription says that this is the Archangel Gabriel, but the image is too faded to pick out much detail. What has not faded however, is the impression of an angelic sweetness, of peace and freedom, rather like the Fayoum angel.

The little tondo of the Virgin, found in a jar in Cairo, was accompanied by a similar tondo of the Archangel Michael. Here the wings, butterfly-patterned, orange, yellow and black, are remarkably prominent. Only the inscription tells us that this ethereal figure, with its waves of red hair, small mouth, and huge eyes, is the warrior angel.

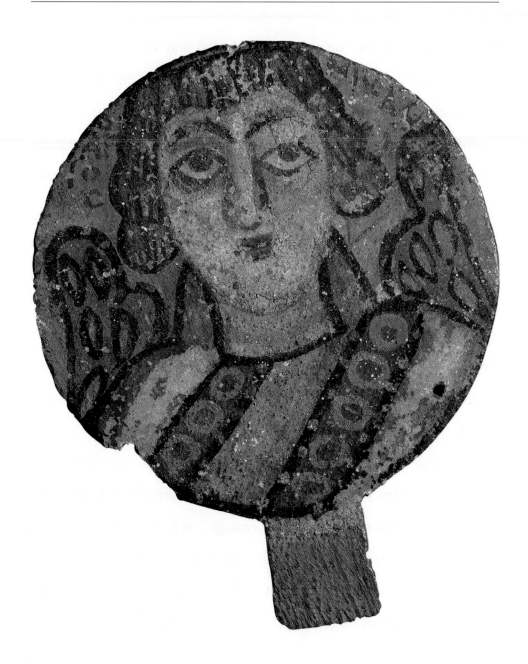

The early Christians were far more conscious than we are today of their closeness to the Old Testament saints. The catacombs abound with Old Testament icons. There are fewer and fewer as time goes on, but Mt Sinai has at least two extraordinary images from our Jewish past. On the surviving right wing of a triptych, we can see a powerful Elijah.

Elijah representing the prophets and Moses representing the law are the two biblical figures who appeared to Jesus during His transfiguration. This great mosaic that dominates the monastic church would have played a formative part in the

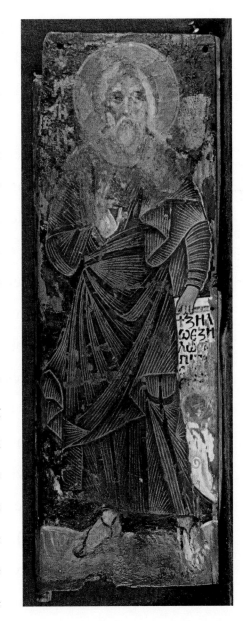

spiritual development of the monks. Not only did Elijah represent the holy wisdom of the Old Testament, but he is called from heaven into the earthly world of Jesus to speak with Him about His passion.

Although the icon has faded, it was once rich with gold and a deep glowing violet colour, and the prophet holds a scroll, announcing: 'I have been zealous for the Lord, the God of hosts.' His other hand, the hand that does not hold the scroll, is raised in blessing. His garment is striped with gold and patterned golden highlights. But it is his face that holds us, faded though it is. There is an ineffable air of patient nobility. This is not the only image of Elijah, but it is the most impressive.

The other Old Testament icon that repays prayerful study is that of the three Hebrews in the fiery furnace. This is a story from the prophet Daniel which describes how these young Hebrew slaves rose high in the service of the King of Persia (they are wearing Persian costumes), but refused to bow down to him as divine. They were therefore to be cast into the burning, fiery furnace. When, next morning, King Nebuchadnezzar and his

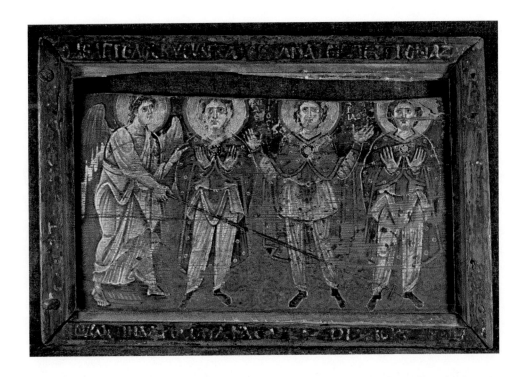

court came to look down regretfully at the ashes of Shadrach, Meshach and Abednego, they were astonished to see all three walking happily and unharmed amidst the flames. Moreover – oh wonder! – they seemed to see a fourth figure walking with them.

Tradition has always held that this fourth figure was an angel, and here he is seen driving away the flames with an angelic lance.

This is an icon that grows upon one the more one looks at it. The three young men, who had fully expected to be burnt alive because of their faith, have expressions of spiritual radiance that are deeply touching.

The angel puts a comforting hand on the shoulder of the nearest youth, yet neither he nor the other two seem conscious of the angel. They are aware only of the wonder of God's providence, and each face is different in its inwardness, its relief and joy. The miraculous preservation of the three Hebrews was a favorite theme in the catacombs, and here we see it in all its freshness and truth.

One of the great gifts of the East to the Universal Church was the establishment of monasteries. All the first monks were hermits, and that is what the word monk means, one who can live alone, with God as his fulfilment. Since icons were not meant to be portraits as such, it is not always easy to know when the picture of a monk is individual or general, whether he represents one unique holy man, or the general aspirations to holiness of all monks. Only the right wing survives of a triptych showing, at the lower portion, shepherds and sheep, (so clearly the missing centre

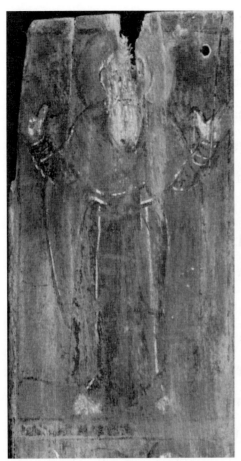

was a nativity scene), and in the other portion, unrelated to the narrative, a bearded monk.

He has a halo, but then, almost by definition, an old monk was a saint. He is wearing the habit of a sixth century monk, a rough, brown tunic with white markings and white borders on his full sleeves. He raises his hands in the familiar position of an orant, a Christian at prayer. Both upper and lower registers of this wing are badly damaged. We can hardly make out the shepherds and the monks, and the wood behind the monk's head is cracking.

I still find this a moving image of what it means to rely wholly on God. The praying hands are empty, because he owns nothing except his habit. The simplicity, authority and peace of the monk's face remind one of those stories that were told and those sayings that were quoted of the desert fathers. These men lived without ego: what could be more blissful?

There are two tiny icons of monks, haloed monks, therefore saintly, that survive from the Monastery of Bawit. These are technically true icons, not painted on walls, but on panels of

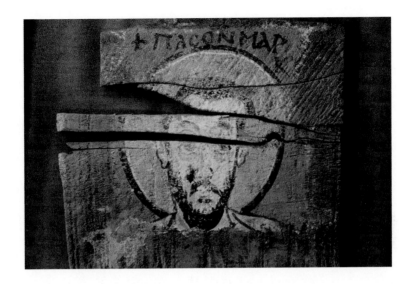

wood and hence portable. They seem to come from the same period of the sixth to the seventh century, yet they are so different as to make us hope that there is an element of pictorial reality here.

Like the abbot Father Menas, whose portrait with Christ is one of the glories of the Louvre, one of the icons has a name: Brother Mark, monk of Bawit.

Brother Mark must have impressed by his goodness, because he does not impress by his appearance. He has a long, thin oval face, very pale and lightly-bearded. His expression is completely

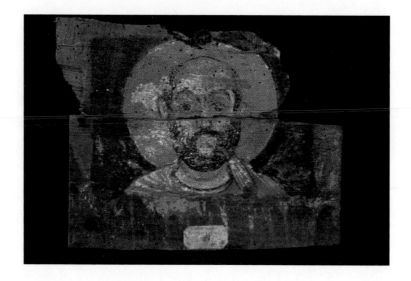

non-committal, which may, of course, indicate that his thoughts are on things above. The other monk, who is rather more interesting, is anonymous. He has a larger face, a brighter halo and a ruddy complexion. He is a far fuller figure of a man, though of both monks we see little more than head and shoulders. Brother Anonymous is bald, well-eyebrowed, and has a neat little beard and moustache. He is as impassive as Brother Mark, and yet one gets an impression of a sunnier and less driven temperament. When we get to heaven, we can discuss all these things and find if our interpretations were correct.

Looking back on what I have written, I feel disappointed. You can judge for yourself: look at the pictures of the icons and what I have said about them, and decide whether my comments have been of any use to you. To some extent, of course, this is just my own inadequacy, but to a larger extent, this is inevitable. I do not think there is any way of 'opening icons up to a viewer', as one can do in Western painting. When one speaks about one of the Old Masters, for example, one is seeking to draw into action the viewer's imagination. The colour, the forms, the patternings, the meaning, often the narrative: all these can be set before another and one's joy in them expressed and shared. But icons do not appeal to the imagination, they appeal to the spirit. They are there for prayer. A true icon is as functional as a pen or a bicycle, and like a pen or a bicycle, it only works when put to personal use. You and you alone must ride your bicycle, or use your pen. No one can take this responsibility from you. Obviously, this is a far graver and more rewarding responsibility than anything material, but it is fundamentally a unique, personal offer of an encounter with God. Only you can respond to this. It is my profound hope

that, looking at these icons from the early ages of Christianity, all who take up this book will feel encouraged to spend time in silence, looking and receiving the blessing of a mysterious but Real Presence.

Here is an anecdote that is dear to me. It is taken from *Desert Wisdom: Sayings from the Desert Fathers* (Doubleday, 1982):

Abba Lot went to see Abba Joseph: 'Abba, as much as I am able, I practise a small rule, a little fasting, some prayer and meditation, and remain quiet, and as much as possible I keep my thoughts clean. What else should I do?' Then the old man stood up and stretched out his hands toward heaven, and his fingers became like ten torches of flame. And he said: 'If you wish, you can become all flame.'

BIBLIOGRAPHY

I consulted many books before I started writing: two were absolutely indispensable.

One is *The Icons*, from the Monastery of St Catherine at Mt Sinai.

Vol. 1: from the sixth to the tenth century, by Kurt Weitzmann, Princeton University Press, 1976.

(Unfortunately this wonderful and beautiful book is out of print.)

The other indispensable book is *Likeness and Presence, A History of the Image Before the Era of Art*, by Hans Belting, The University of Chicago Press, 1994.

(It is impossible to overpraise the intellectual, ascetic and spiritual power of this book.)

Also useful is the *Treasures of Coptic Art*, in the Coptic Museum and Churches of Old Cairo, by Gowdat Gabra and Marianne Eaton-Krauss, The American University in Cairo Press, 2007.

The eight images of the Virgin are described in greater detail in
Encounters With God, in Quest of the Ancient Icons of Mary, by Sr Wendy
Beckett, Continuum and Orbis Books, 2009.

IMAGE ACKNOWLEDGEMENTS

Whilst every effort has been made to trace copyright holders the publishers would be pleased to hear from any not acknowledged here.

Page 3: Photo of exterior of St Catherine's Monastery, Sinai, Egypt. © iStock.

Pages 12, 23, 30, 33, 44, 47, 49, 52, 53, 54, 61, 76, 78, 80, 82, 90, 99, 102, 105, 108, 111, 123: Mosaic of the Transfiguration of Jesus; Icon of Jesus the Pantocrator; Bust of Christ Pantocrator; Christ Enthroned; Crucifixion; Resurrection; Ascension of Christ; Ascension of Christ; Crucifixion; Standing Christ; Icon of the Enthroned Virgin; Virgin of Intercession (detail); Half-figure of Virgin with Child; Virgin enthroned with Child; Nativity of Christ; Icon of St Peter; St Theodore; St Paul, St Peter, St Nicholas and St John Chrysostom; St Athanasius and St Basil; St Chariton and St Theodosios; St Irene; Prophet Elijah; The Three Hebrews in the Fiery Furnace; Praying Monk and Shepherds from a Nativity. Reprinted by permission of St Catherine's Monastery, Sinai.

Page 26: © William Storage and Laura Maish.

Page 27: Statuette of the Good Shepherd, © Cleveland Museum of Art, Ohio

Pages 36, 38, 39, 84, 85, 100, 120, 122: Christ in Majesty, Inv. No. 9789; Christ with angels, Inv. No. 7984; Lunette with angels and the bust of Christ; Tondo with a bust of the Virgin, Inv. No. 9104; Virgin and Child with Apostles, Inv. No. 7118; Icon of St Theodore, the General, and the Archangel Gabriel Inv. No. 9083; Tondo with a bust of the Archangel Michael, Inv. No. 9105. Reprinted with permission of The American University in Cairo Press C 2007

Page 41: Icon depicting Abbott Mena with Christ, from Baouit, Louvre, Paris, France / Giraudon / The Bridgeman Art Library

Pages 60, 93, 94, 97: The Virgin and Child, Saint John the Baptist, Saints Sergius and Bacchus, The Saints.© The Bohdan and Varvara Khanenko Museum of Arts, Kiev, Ukraine.

Page 64: Madonna della Clemenza, sixth–seventh century. Rome, Church of Santa Maria in Trastavere. © 1990. Photo Scala, Florence.

Page 67: Icon of Virgin and Child, Santa Maria Maggiore, Rome. © Foto Gioberti S.r.l.

Page 69, 74: Icon of Santa Maria ad Martyres, Rome. Madonna of San Sisto Photo © B.N.Marconi, Genova.

Page 71: Mother and Child from Santa Francesca Romana, Rome. © 1990 Photo Scala, Florence / Fondo Edifici di Culto.

Page 86: Formerly Bawit (Egypt), fresco in Chapel 28 of the St. Apollo monastery, 7th century.

Page 89: Mosaic with Saint Peter, from San Paolo fuori le mura, Rome, 5th century. Saint Peter's, Vatican City.

Page 109: Saqqara (Egypt), monastery of Jeremias; cell wall, 7th century.

Pages 114, 119: Egyptian panel of St Mark; Egyptian panel of the archangel Michael, Cabinet des Medailles, Paris <<Bibliothèque nationale de France>> Reprinted with permission.

Page 116: Portrait of a saint, 5th–6th century, Egyptian Museum, Cairo, Egypt, J68825.

Page 117: Unknown saint, Florence, Musée archaeologique

Page 117: Portrait of Bishop Abraham of Bawit, Staatliche Museum, Berlin. bpk Berlin, Foto: Markus Hilbich

Pages 129, 130: Brother Mark, monk of Bawit; Anonymous portrait of a monk. Musee des Jacobins, Auch. © Francisco Artigas.